后浪出版公司

发光体2号

Notable Artworks
by
Chinese Artists

Karen Smith

世界图书出版公司

北京 · 广州 · 上海 · 西安

CONTENTS

FOREWORD
Karen Smith: Witness to a World

Karen Smith is the most important chronicler of the emergence of Chinese art. Since she arrived in Beijing in the early 1990s, she has scrupulously attended, processed, recorded, and documented the birth and maturation of an entire world. Her early years in China unfolded at a time before contemporary art was governed by formal systems, and her encounters in those days were mediated by complex webs of personal and professional connections. She spent the 1990s going to exhibitions and performances, talking to artists, and going home to write down her memories and interpretations of these encounters. In a world where things have changed so quickly and thoroughly, Smith's diaries are probably the most comprehensive firsthand account that remains.

Though these early jottings form the basis for Smith's seminal book *Nine Lives,* a snapshot of the contemporary art scene in China through the personal and artistic stories of nine individuals which she authored in the early years of the twenty-first century, much more material from that period awaits publication in her next major book. Meanwhile, as the Chinese art scene has grown and flourished, so has Smith's place in it--she is now not simply a writer but also a curator, an arbiter, and a mediator in the broadest sense, offering her expertise to everyone from major Western institutions initiating projects in the PRC to newly founded Chinese museums looking to establish their taste and credentials. With her partner H.S. Liu, Smith has also acquired a deep expertise in Chinese photography, working on a major photographic history of Shanghai published at the time of that city's 2010 World Expo. But for Smith, even after two decades, the immediate written account remains the key vehicle by which she makes sense--for herself and her readers--of the complexities of Chinese art as they unfold, all around her, in real time.

The *As Seen* project was initiated two years ago by Post Wave Publishing Company, the publishers with whom Karen Smith had worked on several earlier titles including the Shanghai book. The idea was straightforward: Each year, for five years, she would choose fifty exhibitions that she found notable and write short accounts

of them. Accompanied by images, these volumes would become yearly references, reliable accounts of what had happened in a cultural field that continues to morph and grow. The books do not focus on the institutional or commercial developments that are all too often the way we signpost this story; in fact, the name of the gallery or museum where each exhibition took place is given rather secondary billing, collected together into an index at the back. Rather, this is an account of contemporary art over the course of a year told through much as the author experienced it: as a string of encounters with works by individual artists, a strand of aesthetic epiphanies, revelations, and recognitions that follow each other in chronological order.

Karen Smith has been a mentor and friend since I started my own work in China, about ten years after she began hers. During the autumn of 2002, I worked under her to edit the English catalogue for the first Guangzhou Triennial, and I will forever remember our weekly Tuesday morning sessions in her studio going over my translation of a chronology of the 1990s that was to be included in that volume. It was the Oxford tutorial system reinvented for early-2000s Beijing, with me reading my usually inept attempts to render a string of exhibitions and artist names into passable English, while she would expand and supplement the record with her deep firsthand knowledge of everything it contained. It is thus a great pleasure for me personally, and for the Ullens Center for Contemporary Art as an institution, to participate in the publication of this, the second volume in the *As Seen* series. Published simultaneously in English and Chinese versions, and distributed both through the official Chinese system and the international art world system, this volume goes a long way toward creating a common frame of reference for recent developments in Chinese art, both inside and beyond China.

Philip Tinari
director, UCCA

Zhang Xiaogang 张晓刚
Boy No.2, oil on canvas, 60 x 50 cm, 2012

AS SEEN 2

'The ancients would take years to mull over the correct answer to a question. Today we have only minutes to respond.' [1]

The words quoted above, from one of China's leading artists—the painter Zhang Xiaogang—were not, as might be imagined, written recently against the relentless pace of life in China in the second decade of the twenty-first century. Instead, this diary entry comes from almost thirty years earlier, in 1985. At that particular moment, viewed from the surface of society, economic reform was still more theory than practice. A Chinese art world was, however, beginning to emerge, signposted in the middle of that decade by the advent of the '85 New Wave. But even for the small number of artists involved— a tiny number relative to the size of China's population—the pace of life was far from accelerated; if anything, it was calmer than it had been in previous decades, notably during the last years of Mao Zedong's rule, which were marked by a frenetic succession of bitter ideological campaigns.

So if, in 1985, it seemed to Zhang Xiaogang that there were but minutes to respond, today, given the extreme demands of life in China—one of the few nations currently expanding in all directions at full throttle—that response time has been reduced to nanoseconds. There is barely pause for reflection: there is no time to pause. That seems to be true for all, be that artists, curators, critics, collectors, or even the gaze of a burgeoning public audience. No one intends this to be so. Rather, for those engaging with the art world, it is just a fact of having to accommodate an extraordinary number of invites, assignments, exhibitions, lectures, tours and mundane chores. All of that while simultaneously trying to keep up generally with the pace of change that is still perceived as unfolding into a bright new future, the arrival of which no one wishes to impede.

1. Zhang Xiaogang, 9 May 1985, in a letter to "Z.H.", *Amnesia and Memory - Zhang Xiaogang's Letters (1981-1996)*, Peking University Press, 2010, p.68

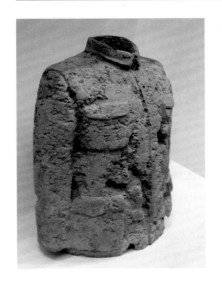

Gao Weigang　高伟刚
Vice, solo exhibition view

Han Wuzhou　韩五洲
Piano e Forte, installation, 150 x 102
x 105 cm, 2011

Sui Jianguo　隋建国
Legacy Mantle No.1, clay maquette,
(h) 40 cm, 1998

The urgency here is both fuelled by the freedom from convention that imbued the Chinese art world with a particular dynamism in the mid-1980s, late 1990s, and early 2010s (as it regrouped after being driven off the rails by the explosion of the art market) and exacerbated by the lack of a cohesive, transparent art-world system. Add to this the emergence of social media as a primary source of information, promotion and publicity, as well as its role as a platform for the exchange of views, and one that demands daily (if not hourly) attention, and time simply evaporates.

If *Weibo* keeps the art world busy, it also increases the pressing nature of an already urgent obsession with "the next big thing". Thus, as artists attempt to keep their careers on track, both the content and execution of works suggest that, in the absence of time to respond, they merely react. Encounters with the resultant works tend to encourage a similarly summary response in critics, curators and even audiences. In terms of the "contemporary", the air of awe and meditative contemplation once associated with the experience of art is ever more diluted; the notion of a tortured artist engaged in a passionate search for meaning in life and a sense of the eternal is, it seems, officially dead. Well, almost.

This question of response versus reaction arose while preparing for this volume, and from surveying the volume of art recently produced in China, but this phenomenon did not spring up overnight. The problem is partly rooted in what generally constitutes post-postmodern art; that which is termed "contemporary" art. There is an air of duplicity in the nature of much art that aligns itself with this label, and not just in China. But in China, against the ongoing rush to internationalise and compete, and more, that duplicity can seem pronounced in a seam of art that, superficially, has all the right qualities and ticks all the right boxes; that speaks to the moment, to the perceived socio-political mood. But, when prodded, these elements are sometimes revealed to be red herrings: like a stage set with its painted backdrops and clever illusions. Not all art falls into this mire, of course. The key is weeding out the followers to give the leaders their full due.

In identifying strong works, one trend did suggest itself: a small number of significant artists appears to be opting out of the fast lane, taking a step back behind the front line to carve out time for a closer engagement with a personal value system as the core of their work. Gu Dexin's decision to retire entirely is an extreme example. Ditto, Geng Jianyi who has always been true to his particular stance, even if that meant disappearing from public view. More recently, Zhang Xiaogang and younger artists like

Zhang Peili 张培力

480 Minutes (detail), colour
30-channel video work, 480', 2008

Yangzi Yangzi

Dialogue, colour two-channel video,
45', 2012

Double Fly 双飞

Death in Basel, colour single-channel
video, 17' 47", 2011

Liu Wei, Cao Fei and even Hu Xiaoyuan have each demonstrated a desire to take back control of the creative process.

The front line in China today is dominated by highly active young artists, a good portion of them, as I hope this volume demonstrates, producing exciting, innovative art. The best are defined by the energy and assertiveness they deploy through intuitive and unhesitating gestures and actions. Their works capture brilliant instances of vision. Their liberating and fearless path of "anything goes" leads to real innovation. If that's hard to spot at times it's because there is a far larger volume of artists producing art—this, the duplicitous portion—that is simply "anything you can get away with." The problem is that the resulting artworks can appear disparagingly similar to the innovative pieces, which is great for clever individuals with a talent for imitation, but not so great for innovators deserving of attention.

"Anything you can get away with" as an observation of some art is not a recent thing, but words published by the venerable Marshall McLuhan, often described as a twentieth-century seer, in his seminal 1964 publication *Understanding Media*. McLuhan also wrote: "We look at the present through a rear-view mirror. We march backwards into the future." Events and attitudes in China show that to be a largely Western perspective. Contemporary art in China has little relation to history in the Western sense of continuum. Today, in terms of the cultural sphere, there are, for example, no museums where an overview of modern and contemporary art can be seen. And there are too few books on the evolution of China's contemporary art forms; not a single tome viewed by consensus as objective or factually reliable.

The mindset of artists at work today feels unconsciously closer to that of the Italian Futurists, active a hundred years earlier, than any other state in evidence today. Yet the Futurists sought to destroy an "old world"—with museums they described as graveyards—that was deemed irrelevant to their future. In China, the art world increasingly sees the museum as an ultimate resting place: hence, perhaps, the astonishing volume that has, in recent years, sprung up across the country. We need rear-view mirrors. They show succeeding generations where they came from, warn of the pitfalls of unregulated human acts, and mark what has been overcome to endure the passage of time. Sentimentality aside, they offer confidence more than comfort per se. In China, the lack of an effective rear-view mirror is signalled by the ongoing state of nostalgia—a yearning for a different time that effectively obliterates history—revealed in the work of artists such as Zhang Xiaogang, but also Chen Wei, Utopia Group, Hai Bo,

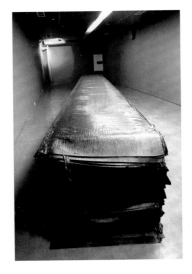
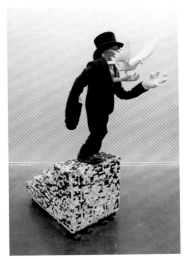
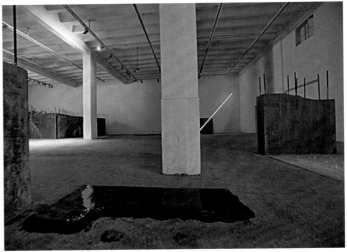

Wang Guangyi 王广义
Sacred Object, oil cloth, lime, sand,
120 x 80 x 1000 cm, 2012

GUEST GUEST
Standing on the Shoulders of Little
Clowns, exhibition view, 2012

He An 何岸
Detail of installation, Who is Alone
Now Will Stay Alone Forever, 2012

Xie Nanxing 谢南星
Velasquez' Innocent X, oil on canvas,
150 x 200 cm, 2010

地税局

Local Taxation Bureau

宋 **Song Ta**
拓 *Civil Servants* (detail), drawing on
paper, 600 x 200 cm, 2012

and even Wang Wei. So although nostalgia may have little to do with an actual past, if the Chinese art world kept a better eye on the rear-view mirror it might see that Western art history is an exclusive and somewhat limiting club, at odds with the diversity that is to be found within China' s own cultural framework today; a diversity that, due to the power of art world forces driving the "contemporary", is in danger of being undermined. But while the absence of a "rear-view mirror" may or may not hinder the wholesome growth of artistic careers and practice in general, it is impeding the development of local critical parameters, of a factual history of art, and of a broader public audience. By extension, the question of what art is, or can be, gains an urgency all its own.

As Cao Fei demonstrates in her *Secret Tales from the Museum*, that question is increasingly relevant to the growing number of ordinary people who have already demonstrated a fascination for contemporary expression—the strangeness of its manifestations as much as its value as currency. For the best of today's art to find a place in art history it must contain enduring values—human, aesthetic, philosophical or political—as representative of this era, which itself will only be seen clearly with hindsight, in a rear-view mirror. That too will be the test of the responses and reactions in the selection of works included in this series; a test of the process of documenting art within a specific time frame, attempting to record the mood of a moment, the values and fascinations that drive the work. These responses took a considered amount of time; but only time will tell whether that matters or not.

Hanif Kureishi Intimacy

Edited by BRIAN MacARTHUR

The Penguin Book of TWENTIETH-CENTURY

PROTEST

WHAT IS THE ARTIST'S ROLE TODAY?

QUEL EST LE ROLE DE L'ARTISTE AUJOURD'HUI?

LEFEBVRE everyday life in the modern world

张奕满 | Heman Chong

A Stack

Singaporean artist Heman Chong (b. 1977; Muar, Malaysia)
graduated from London's Royal College of Art in 2002.

The Singaporean artist Heman Chong demonstrated a sentient degree of restraint and craftsmanship in the execution of a work he titled *Everyday Life in the Modern World, What is the Artist's Role Today? Protest, Intimacy.* The piece in question took the form of an assemblage and consisted of several empty perfume bottles (of a popular and readily identifiable brand) that had been carefully placed upon a pile of books. The entire ensemble was placed modestly on the floor. It is a form, and a process, that Heman Chong refers to as a "stack".

I have not had a full experience of the half-dozen or so pieces in this series, which is called Stacks, to speak about the project as a concept. I have, however, seen enough to know that not every one of them works equally well—certainly not in the way that *Everyday Life in the Modern World* was successfully able to convey a complex picture of the artist, his mindset, and of the world he inhabits using a modest, succinct shorthand. In terms of what the works set out to achieve, well, that is not an unimportant reference; the Stacks series to which *Everyday Life in the Modern World* belongs are akin to a form of self-portraiture. Heman Chong produces one a year, achieving the small assemblage through a selection of unassuming, familiar items.

The commonality underlying the series is explained in the word "stack", each portrait being a stack of objects, which habitually includes books that the artist has read in the course of a calendar year and have proved memorable for a variety of personal reasons. As representatives of ideas or concerns that are on his mind through a particular period of time, the selected books are then harmonised with an object or two reflecting a contrasting or complementary nature of those narratives and philosophies of life. The first *Stack* was produced in 2003; *Everyday Life in the Modern World* was number three in the series. Elegant and simple, this work had a weight that lay in its clarity. Even from down there on the gallery floor, it said this artist knows who he is, asserting a comfortable self-

◄ *Everyday Life in the Modern World, What is the Artist's Role Today? Protest, Intimacy*, 4 perfume bottles, 4 books, variable dimensions, 2005

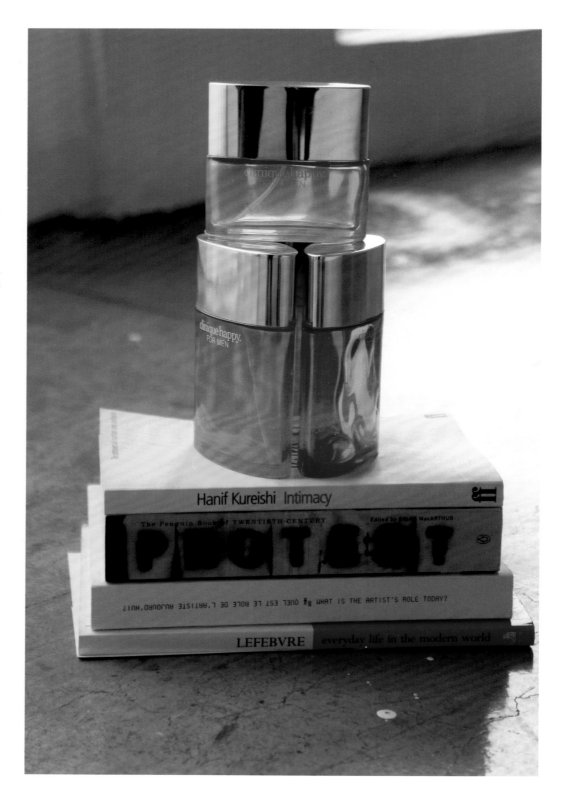

acceptance through the subtle observation of things important to him—important enough to have been chosen to represent the artist in this Stack.

Heman Chong describes himself as an artist, curator and writer. He trained as a designer—a fact that might account for the sentient feeling for perfectly matched form and function here. In the case of this particular work, its appeal lay in the warm, lush and even colour combination—the bottles being of a treacly tangerine orange that felt orchestrated to seduce—as much as the contents of the objects combined into this delightful assemblage. *Everyday Life in the Modern World* was succinctly suggestive of intrinsic qualities: from intellect to personality, from artistic concerns to appearance, from training to vision.

In terms of his writings, Heman Chong has a penchant for speaking of himself in the third person, something that might encourage the distance from "self" required for a clear appraisal of character, which he seems to have achieved with *Everyday Life in the Modern World*. He claims to take guidance for making art from the author Kurt Vonnegut, who once said: 'Give your readers as much information as possible as soon as possible. To hell with suspense. Readers should have such complete understanding of what is going on, where and why, that they could finish the story themselves, should cockroaches eat the last few pages.' Indeed, in affirming his approach, Heman Chong states: 'I don't mince words and I don't see why my art work should mince words. If there's something to be said, just say it in the least confusing manner possible.' Looking at *Everyday Life in the Modern World*, that much was clear.

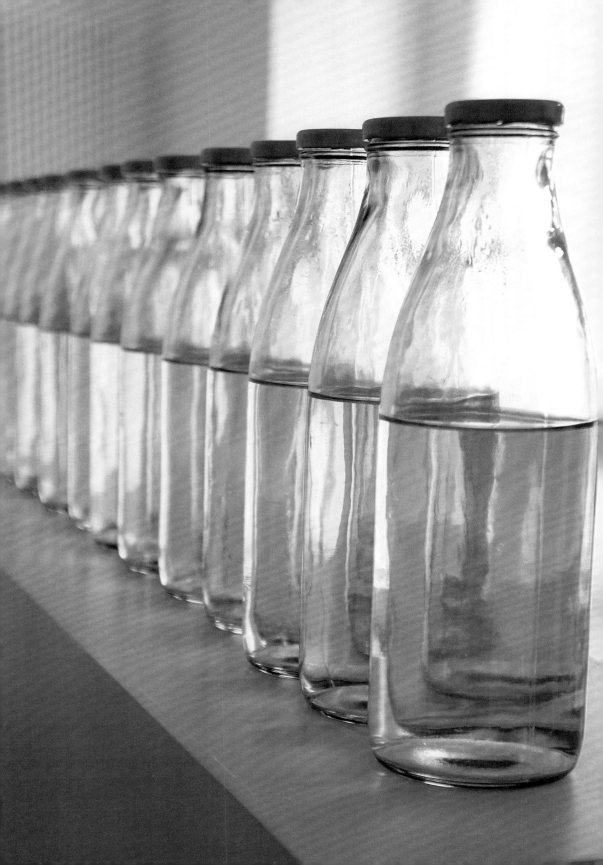

Pak Sheung Chuen

The Horizon Placed at Home (N22°17' 400" Version)

Fujian-born artist Pak Sheung Chuen (b. 1977; Anxi, Fujian) moved to Hong Kong, where he is now based, in 1984. He graduated from The Chinese University of Hong Kong in 2002 with a major in fine arts and a minor in theology.

Where Hong Kong-based artist Pak Sheung Chuen's installation was visually distinguished by the character of transparency, the ambient wintry light that suffused the exhibition space played a significant role in etching the work on the memory. Touched by the warm, weak haze of the early afternoon sun, the piece was illuminated with an ethereal, inner incandescence, which was, fleetingly, mesmerizing. Conceptually and visually, the work could not have been simpler, so perhaps I was just lucky to arrive at exactly the right moment to catch the work ablaze. As the light faded, the life withdrew back into the glass forms as if a genie sucked back into a lamp, at which point the bottles became, well, simply bottles: a collection of forty-five almost empty containers.

Not quite, though, for in *The Horizon Placed at Home*, the plain, clear bottles were each filled with samples of water drawn from Hong Kong's Victoria Harbour, taken along the length of an east-west axis representing 'possibly the longest horizontal route between the eastern and western peninsulas of Hong Kong Island any ship can sail in the harbour' without deviating around land obstacles. In 2009, having plotted this course, the artist collected a set volume of water every hundred metres—art, then, as sociological investigation, aimed at revealing something about the condition of the water in a working harbour (generally) and the South China Sea (specifically).

Once corked within an airtight stoppered bottle, over time, the algae in the water—or whatever other specific elements exist that alter water's balance (or are altered by it)—began to cultivate small colonies. The water turned cloudy in parts, or developed clusters of curious green matter, which hover in suspension in the hermetic domain of these bottles, yet subtly, the incremental stages of its advance as to be invisible to the naked eye. After almost four years, the water was, for the most part, remarkably clear, with only the odd hint of green.

The bottles were placed at chest height on a plinth in a single, perfectly appointed row, thereby making *The Horizon Placed at Home* a precise and clean

◄ *The Horizon Placed at Home* (detail), bottles, water, map, 2009

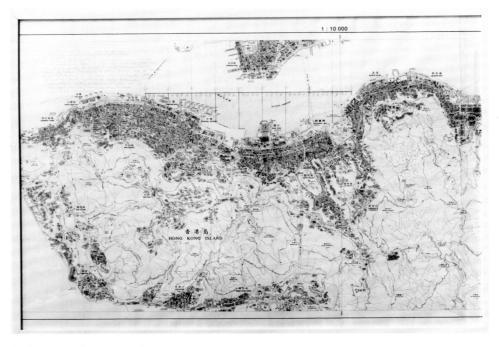

▲ ➤ detail of map and bottles

visual statement. Superficially, perhaps, this arrangement initially pointed to a seeming sameness: the bottles were ostensibly no different from one another, having been created for the same purpose (milk), and cast from the same mould. But glass is a living thing itself, which refuses to be tied down by exactitude. Bottles of this kind are approximately alike at best—the tiny, nuanced distinctions evident here appeared to be in the same measure as that of the water they contained.

This formal lineup suggested an act of minimalism, possibly, but, more to the point, it was experienced as a perfectly articulated illustration of the problem of water—its lack (in this part of the world in northern China) and how easily it can be polluted through carelessness as much as ignorance—matched by an effortless eye for aesthetic order. That is not usually so easy to achieve without appearing gauche and this was a wonderful piece of artistry. Less immediately obvious was the accompanying map, which outlined the route the artist had taken, and brought the work back from the easy comparison with a minimalist setup to the kind of documentary form that Pak Sheung Chuen uses to produce artworks; *The Horizon Placed at Home* is one of a series of similar pieces that each explored the quality of the horizon at a number of chosen sites in Asia and elsewhere. In 2009, *The Horizon Placed at Home* was presented in Venice when Pak Sheung Chuen represented Hong Kong at the Venice Biennale—a site at the mercy of surrounding waters; in Beijing, where water is so scarce, the content and issues at stake had infinitely greater resonance.

20

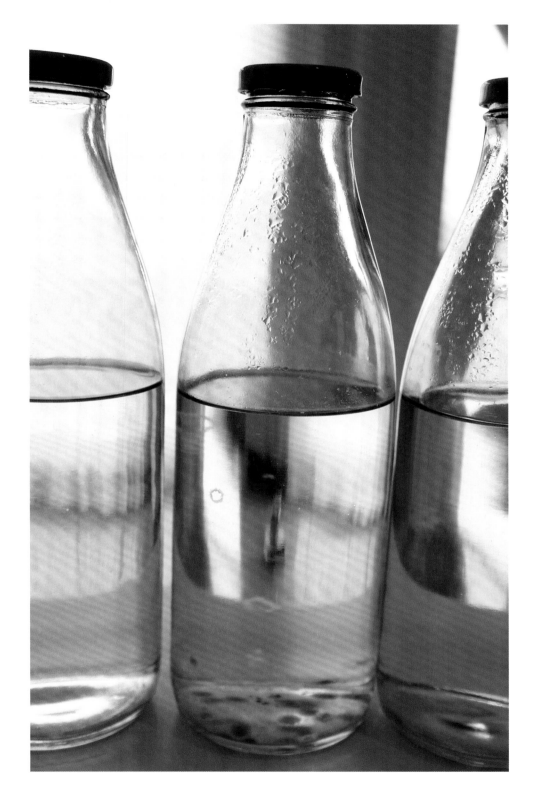

骆丹 | Luo Dan
Simple Song

Photographer Luo Dan (b. 1968; Chongqing, Sichuan) graduated from the Sichuan Fine Arts Institute in 1992.

'When I first looked at these photographs,' wrote fellow photographer Yan Changjiang in the catalogue to the exhibition Simple Song, 'I thought they were a poetic religious hymn with no bearing on reality.' An initial glance at this extraordinary collection of photographic works could be exactly that misleading. Luo Dan's portraits of minority groups living in the remote mountain area of the Nu River gorge, in the southern province of Yunnan, appeared to have been retrieved from a previous age; appropriated, re-photographed and re-presented as an artist's take on the past, on the conventions of the photographic medium or, simply, of seeing.

This practice of appropriation and re-interpretation is almost de rigueur in art today, yet that is not exactly the case for Luo Dan's choice of subject and approach in Simple Song. He took these photographs as portraits of people he encountered and who he invited to sit for him during the course of a year-long journey through this region from 2010 to 2011. If the people in the pictures, splendid in their native costumes, appear to be not of our time, it is because they live at such a removed distance from those parts of China which, in recent decades, have been subjected to major industrial and cosmetic overhaul; they live in a place that bears little relation to the contemporary moment. 'To the minorities, there is no sense of modernity,' the artist wrote in his own preface to the exhibition. 'Time [in the region] remains in its original state.' He further noted, however, that modernity, in the form of hydropower stations, was coming to the Nu River valley, which meant that time would eventually overtake these people. The photographs examine what might be lost.

Luo Dan is a born traveller. In 1997, he began working professionally as a photojournalist, but the desire to go in search of himself soon set him on the road, literally, as well as in terms of seeking artistic independence. His first series, *On the Road — Highway 318*, followed the length of this highway from its beginning in Shanghai all the way west to the border with Nepal. This was followed by a similar

◄ *Simple Song No.21: Xiao Fucai and Na Aye, Mugujia Village,* black and white photograph, 2010

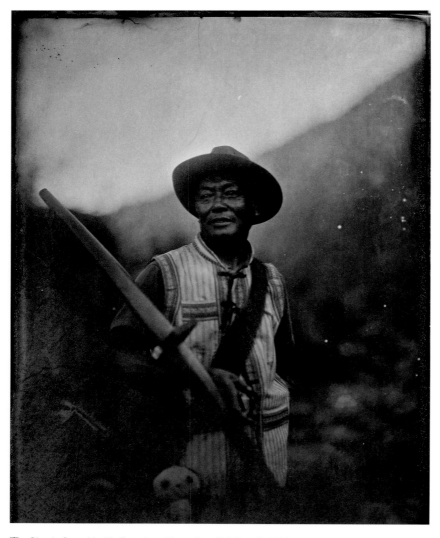

Simple Song No.18: Crossbow Champion, Kai Siye, Shidi Village, black and white
photograph, 2010

journey, for a series titled *North, South,* from the Russian border in the north of China
all the way down to Guangzhou in the south. To travel in this manner is something Luo
Dan's generation finds natural today, but that, as recently as the mid-1990s, was for
older generations subject to a range of ambition-curbing restrictions. The long cross-
country journeys taken by China's young pioneers in the 1960s were not enlightenment
pilgrimages but mass rallies propelled by ideological goals that sought to unify the
diversity they encountered, and thus not the same thing at all. Luo Dan is somewhat
unique in being a modern-day adventurer, willing to commit himself to spending as long
as is required on the road for this cause of seeking out difference.

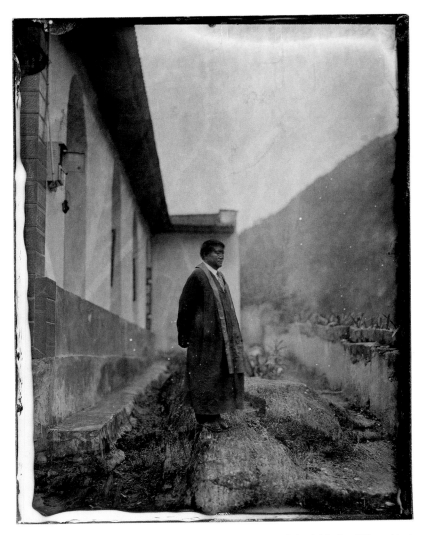

▲ *Simple Song No.8: Sang Lusi, Pastor of the Bible Training School, Munima Village,* black and white photograph, 2010

On this particular journey to the south, preserving the present exactly how he found it was important to Luo Dan. It guided his choice of camera, as well as the technique—known as the wet-plate collodion process—that he brought to producing the photographs. The use of this early photographic method enabled Luo Dan to visualise time by confusing the present through a conscious link to the past. British photographic pioneer John Thomson used the wet-plate collodion process on his travels in China during the 1870s. Photography at this time was at a point where it had attained just enough portability to make travel photos a possibility. As such, Thomson became one of several foreigners to explore China though a lens, and is credited with creating the first

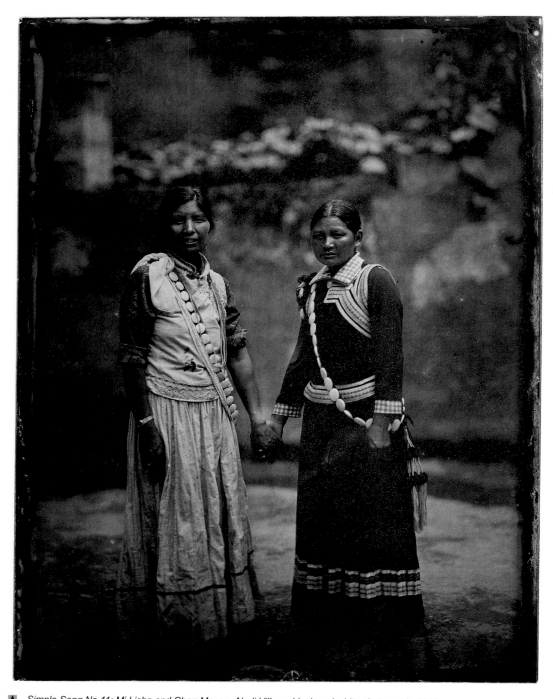

▲ *Simple Song No.11: Mi Lisha and Chen Mayan, Aludi Village,* black and white photograph, 2010

real portraits of Chinese subjects. His images ventured beyond "native types" to find a human presence in a personal moment; Luo Dan may claim a similar achievement.

The wet-plate collodion process involves preparing a plate (the negative) on the spot. It requires skill. The plate must be pristine clean and the magic, light-sensitive liquid poured to an even film across the surface. The scene to be captured has to be identified first before preparations begin. And, in the time taken to complete the work, the subjects are required to wait—those of Luo Dan's series today, just as those of John Thomson's photographs almost 150 years earlier. The pause involved presumably allows for a greater awareness of the moment about to be preserved for posterity, which might account for the dignity and calm with which Luo Dan's subjects are steeped. Luo Dan may also add that this aura can be attributed to the innocence of these humble people—from the depth of their faith and the comfort that they draw from it, especially as local culture in this region is, in part, distinguished by its Christian beliefs. It is not obvious from the portraits, but approximately 70 per cent of the Lisu and the Nu minorities here are Christians. The group title for the works, Simple Song, is a reference to local folk music, the lyrics of which describe missionaries bringing Christianity to the people of the Nu River valley.

Each portrait captures the subject in the midst of their daily life, paused momentarily to accommodate Luo Dan's request. If that still seems astonishing, it is a measure of the dramatic redevelopment of the urban centres across China, which has taken place over the last thirty years—particularly the last fifteen—but which is far from the reality experienced by the rural population. That population is dwindling, for no other reason than the allure of what, by comparison, are the increasingly futuristic cities. How can youth resist this modern world? But the mood of Simple Song was no lament. Rather, Luo Dan's photographs could be viewed as lyrical, idealistic ballads— his work preserving an image of an alternative life, one perhaps more eco-friendly, and to which some amongst us wish a return. This show was not just about the dress and the landscape featured. Nor was it even the process used that enhanced these images. But, more precisely, the power of photography to transport viewers to the place and time in which an image was captured, even if that time was but a few short months ago.

李然 | **Li Ran**

Mont Sainte-Victoire (and other points of reference)

Beijing-based Li Ran (b. 1986; Hubei) graduated from the Sichuan Fine Arts Institute, 2009.

With a small group of five works, presented variously in a range of locations in Beijing, Shanghai and Guangzhou, Li Ran was the most interesting new presence to emerge in 2012. He won praise for his first work, *Mont Sainte-Victoire*, which Hong Kong and Beijing-based curator Su Wei described as 'providing a real point of reference for our art system'. The question of a system for China's contemporary art has been under discussion since the birth of an avant-garde scene in the early 1980s. Where Li Ran's work forged its point of reference was in the artist's examination of Western art history in terms of the influences that have shaped the path which artists in China—whether as trailblazers or as followers, or those hoping to subvert the journey by diverting the path in an independent direction—have followed through the recent several decades. For good or bad, the results of those influences, today, are the possibilities provided to all artists, such as Li Ran, to challenge the status quo and open the field to debate.

As a live performance, *Mont Sainte-Victoire* placed certain demands on its audience, not least their attention. The action centred on Li Ran delivering a monologue that involved multiple perspectives, each one "played" by the artist, and to which he brought an extraordinary vocal range. A meticulously constructed text, it tracked a concise history of art, from Cezanne to now, playfully unravelling the succession of ideas upon which this history is predicated, but from a local, twenty-first century perspective. If Li Ran's text accepted history as a series of actions, and the consequences born of those actions, it also asked questions about the standards and values brought to adjudging those actions, and artworks, in the context of today.

Through words Li Ran ascribes to Cezanne, this father of modern art is made to wonder if, in imitating reality on canvas, as he does when depicting nature, he is himself an imitator, too. At what point, Li Ran muses, does this vein of imitation, in the manner of Cezanne, become innovation? Today, now we are so much further down a road littered with ground-breaking gestures, what does innovation in art mean? 'We

◄ *From Truck Driver to the Political Commissar of the Mounted Troops,* black and white single-channel video, 8' 51", 2012

A ➤ *Mont Sainte-Victoire*, performance and slide installation, 2012

are staring in the face of a profound conundrum,' one "honest narrator" declared, 'the approach of a dead end. This kind of deadlock does not arise from a lack of artistic styles or a dearth of creativity. Instead it arises from a lack of faith in anything. I am afraid that we have enslaved ourselves to history.'

The research and thought brought to developing the scenarios, and the issues upon which they pivoted, were impressive. The performance would have been brilliant were it not for the audience's indifference to the artist-actor in their midst. Attention withheld, it became impossible to hear (much less enjoy) the intricacies of the argument above the general babble in the room. Fortunately, the performance was recorded and played back in the space throughout the duration of the exhibition. Returning when the crowds were gone, it was possible fully to hear perspectives drawn from different periods of time and across vast geographical distances. And, to do so while viewing a slide show of master artworks, projected in the space to reflect the span of time ensconced in the text, and the cultural nuances of the artists invoked.

Twenty years earlier, Shanghai-born artist Li Chao declared *I Don't Want to*

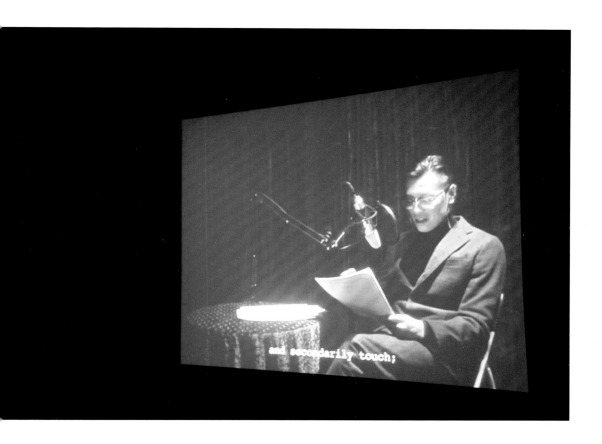

Play Cards with Cezanne in the title of a painting that also invoked the French artist's Mont Sainte-Victoire series of oils, and seemed to question the relevance of Western art to contemporary practice in China. Li Ran's invocation of art history via Cezanne demonstrated how well equipped today's young generation is to articulate these issues with the force of intellectual reason.

In contrast to the complex ideas *Mont Sainte-Victoire* raised, Li Ran's second piece of note, *Beyond Geography*, provided light relief in the form of a multi-channel video—spoofing natural-history documentaries of a format that stretches back to the early days of BBC-funded expeditions of discovery—and proved particularly popular. The video work showed Li Ran, in the role of a modern-day David Attenborough, embarking on a journey in search of the imaginary Shynna Babajiaharo tribe. 'One hundred years ago, British explorers glimpsed a tribe that no one has seen since…' began the narrative. Employing almost every cliché associated with adventure as television entertainment—primitive people untouched by modernity; living in ways unchanged for centuries; at one with nature, and maintaining the ecological balance

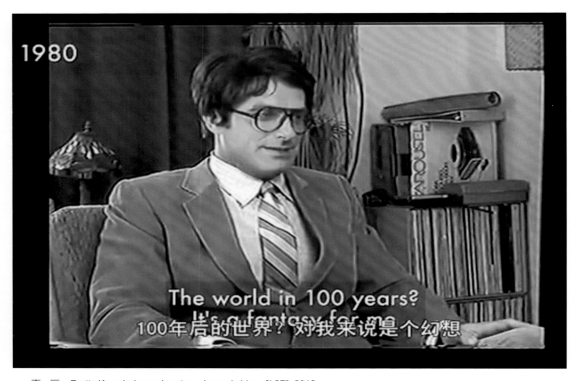

1980

The world in 100 years?
It's a fantasy for me
100年后的世界？对我来说是个幻想

Pretty Knowledge, colour two-channel video, 6' 27", 2012

that developed societies have lost or are destroying—viewers appeared to embrace the trek in eager anticipation of discovery. The joke is that the entire journey unfolds in a studio against a blue-screen set, which Li Ran makes no attempt to conceal, most obviously when he describes patterns on a rock face as being 'like Matisse, Mondrian, Pollock, and Chinese painting'. Viewers trust the convention and are amused by the fictional deception.

Following a night of terror, captured *Blair Witch* style with an infrared camera, Li Ran excitedly stumbles across the tribe. These innocents are at first scared of the camera until, to predictable expressions of awe, they gaze upon images of themselves. They touch and smell Li Ran's hair; his clothes. He ponders the meaning of the tribe members' tattoos and the hierarchy these markings represent. He asks that they paint his face, which allows him to describe a mix of awful materials used to create the pigments. Watching the tribe engaged in a mutual grooming session, and observing

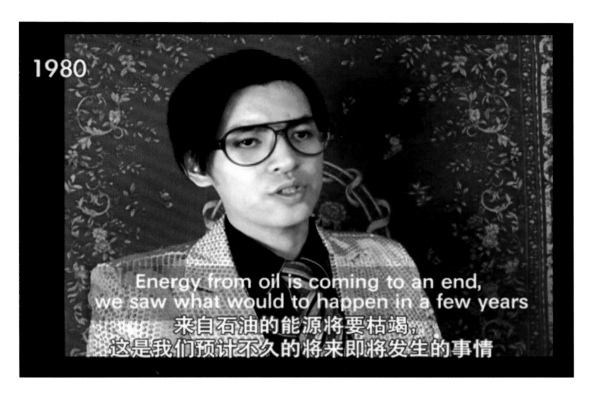

their native courtship ritual, reminds our guide of Gauguin's great questions: where do we come from, where are we going, and why? Li Ran's embrace of the primitive with a politically correct sense of equality is suitably patronising, which challenges the work's viewers to consider the attitudes held towards so-called "exotic" or unfamiliar cultures.

Two further works were equally pointed in their play on cultural characteristics ingrained to the point of becoming institutions. First, the tragic soul of the Russian farmer-solider, the subject of a century of that nation's greatest literary works, was enacted in *From Truck Driver to the Political Commissar of the Mounted Troops*, a title replete with its own delicious edge of irony. Second, the existential inclinations of French culture were embodied in a parody of the recent revelatory psychic whose predictions about the future, supposedly made in 1980, went viral on YouTube in 2012. Li Ran described the former as concerning 'memory ... not towards the past, nor towards the future, but ... in a modern consciousness'; the latter, *Pretty Knowledge*, spoke to the

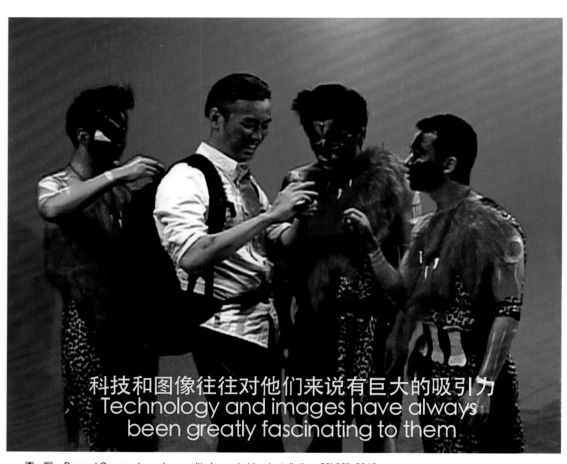

科技和图像往往对他们来说有巨大的吸引力
Technology and images have always
been greatly fascinating to them

▲ ➤ *Beyond Geography*, colour multi-channel video installation, 23' 09", 2012

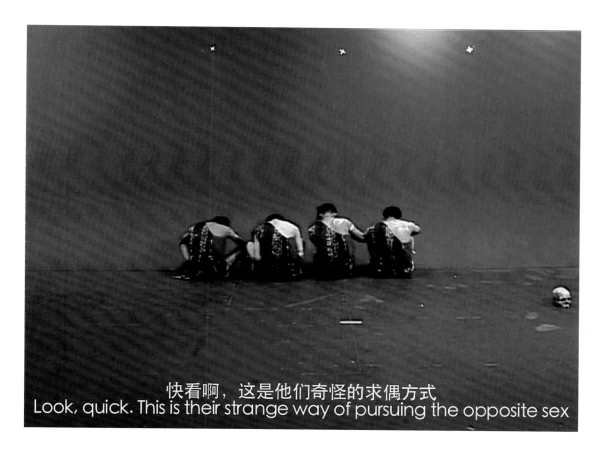

快看啊，这是他们奇怪的求偶方式
Look, quick. This is their strange way of pursuing the opposite sex

present—as "the future" in the revelations—and mocked the guile that fosters faith in the seemingly impossible (in this case that Earth would soon be ruled by aliens). Both were performed by the artist, filmed using minimal sets and means, but with such deftness and sleight of hand as to be utterly convincing—at least as convincing as the French psychic's spoof—as Li Ran intended them to be. 'I care only that the materials are appropriate to my expression,' he states. Thus far he has yet to give the slightest appearance of being inappropriate.

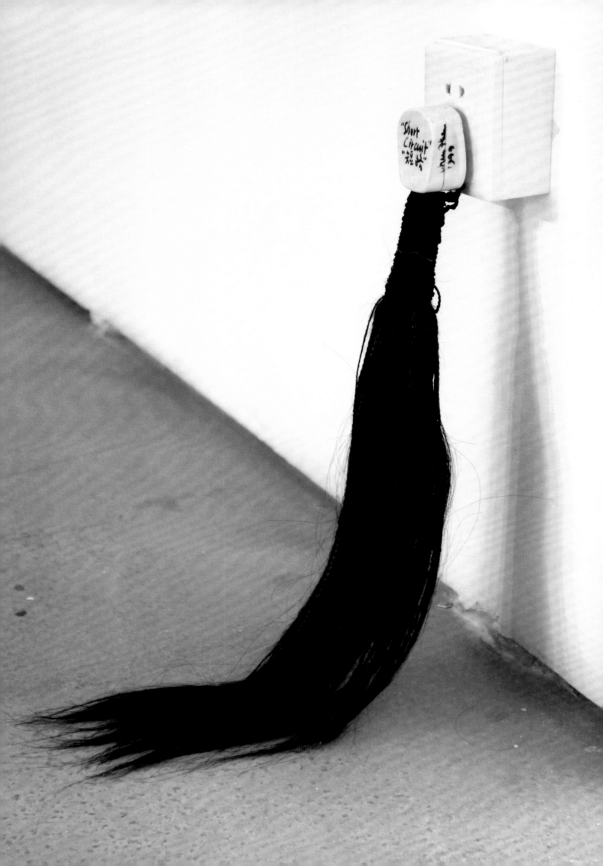

陈 箴 | Chen Zhen

Same Bed, Different Dreams

Shanghai-born Chen Zhen (1955-2000) graduated from the Shanghai Academy of Drama before moving to Paris in 1986.

Chen Zhen's untimely death in 2000 denied the growing public audience for contemporary art in China the opportunity for a proper introduction to his work and a sustained engagement with his art. While Chen Zhen's reputation lives on, he was never a prolific artist, and the works that he left to history, modest in number, are spread out among his followers and collectors. Opportunities to see more than a single example of his oeuvre in any one place are rare, yet absolutely essential if his legacy is to carry the weight that the artist achieved during his own lifetime.

Same Bed, Different Dreams was one of those rare moments. The show represented the first major gathering of Chen Zhen's works in Beijing since the memorial exhibition organised by curators at London's Serpentine Gallery in 2001. Hosted by Faurschou Foundation, in Beijing's 798 art district, and in collaboration with Galleria Continua, 2012's Same Bed, Different Dreams pooled the resources of their respective collections—the largest concentration of his art in private hands—with works that broadly covered the period 1992 to 2000, as well as a range of materials and forms that are considered representative of Chen Zhen's practice. As a conceptual artist, his works were frequently site specific in nature and, on occasion, ephemeral in the elements with which they were constructed. Preserving them has clearly been a labour of love.

As encapsulated in the poetry of the title, Same Bed, Different Dreams captured the intelligent, lyrical artistry of Chen Zhen's work. If understood in terms of the present day, of the modern world we now live in, were we not all born unto this same bed? And as Enlightenment thought tells us, as individuals, were we not also born to pursue different dreams? As his work demonstrates, Chen Zhen felt there was work to be done on both fronts. As the enlightened being that he was, he also saw no barrier to achieving this ideal, eventually, even though in his youth it had to be pursued abroad. That, perhaps, only heightened the sense of mission with which he imbued his work. To

◀ *Short Circuit*, object: plug and hair, 1999

A Village without Borders, chair, candles, 2000

be an artist was, for Chen Zhen, a means to bringing a new understanding of the world to ordinary people, couched in the visual language of art. He saw art as being without border or boundary, which was, in a way, evidenced by the fact that this Chinese artist was embraced and celebrated in France as being French.

If Chen Zhen's life and career were curtailed by terminal illness, then equally, that same illness, with which he wrestled from childhood, was also a source of energy and inspiration. The ongoing engagement with the healing process, the parade of doctors who attended him, and the inevitable fact of daily medicinal intake, was ingested and transformed into a holistic vision of the world: a world not to be feared for its strangeness or the threats to life that it brought. It also motivated the element of transformation upon which so many of Chen Zhen's works rest—he not only found new and unusual uses for all manner of household objects, but, in the process, he imbued them with a magical quality.

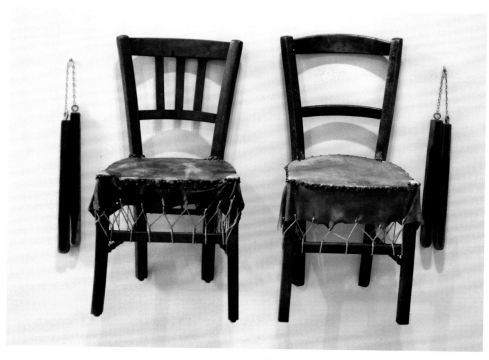

Un-interrupted Voice, chairs, animal skin, 1998

It was the quieter or smaller pieces that were most memorable among the works shown here, such as the unassuming *Short Circuit* from 1999, a simple power plug adorned with a pony tail, which might have easily passed unnoticed in the shadow of the grand gesture that is Same Bed, Different Dreams—a Chinese-style built-in bed, with sweeping drapery and a range of jarring components, which lent its name to the show's title. A pair of tiny chairs from his *A Village without Borders* (2000) series offered something similarly simple, their seats occupied by a house-like structure, which was fashioned from coloured candles to resemble nothing so much as a votive offering or home shrine.

A second pair of chairs, titled *Uninterrupted Voice* (1998), had their seats covered with the same animal skin that Chen Zhen used to transform an array of objects (from chairs to bed frames to wooden barrels) into functional drums. Unlike the bigger surfaces such as those created by the use of a bed frame, which demand a good swing, these chairs asked to be struck softly. With its light-hearted title, *Exciting Delivery* (1999) presented a succinct image of fragility: a snaking coil of rubber inner tubes massed to Medusa-like proportions on a three-wheeled bicycle; a hint of the challenges of steering

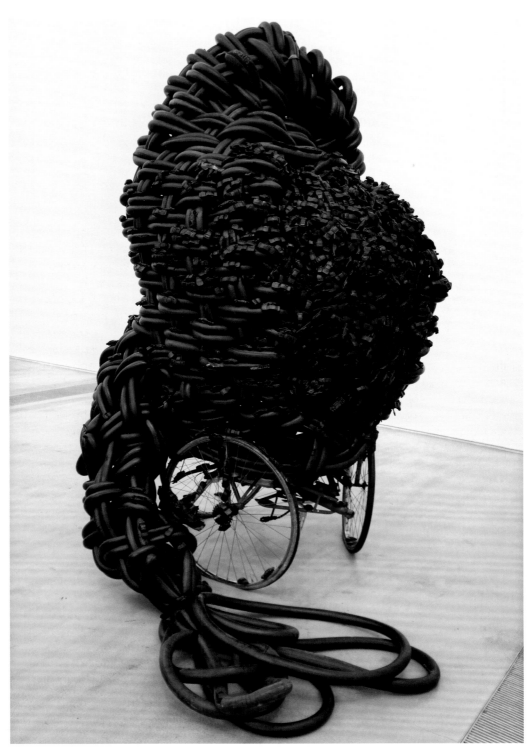

▲ *Exciting Delivery,* three-wheel cart, rubber inner tubes, toy cars, 250 x 130 x 135 cm, 1999

expanding expectations that are not set on a firm foundation, echoing Chen Zhen's belief that 'man's endless pursuit of material wealth can only result in ecological disaster.'

A sense of balance, in relation to the kind of imbalance that puts the world out of whack, was an element present in many of the forms Chen Zhen created. None were quite so prescient as the collection of bright transparent objects that, as the title *Landscape of the Inner Body* (2000) suggests, took the shape of internal body organs fashioned from handmade blown glass. Wherever the work is exhibited, the external world is, as has been said, 'reflected in the crystal surface of the "interior" landscape' that is represented by the organs, thereby 'underlining the relationship between internal and external causes, between the human body and society'. Balancing opposite forces lies at the heart of Traditional Chinese Medicine (TCM) and, following Chen Zhen's profound interest in this subject, is perhaps the ultimate prism through which his work should be understood: his ultimate goal in art being that of balance and harmony.

The final work here was *Memory* (2000), which was conceived as a way to achieve racial harmony by appeasing the frustrations fomented in people labelled "different" by an indifferent world. It was originally part of a seven-piece series by Chen Zhen called *Six Roots*. The titular "roots" referenced a Buddhist allegory of the human senses. Inspired through experiences accumulated during a visit to Zagreb, and created as a poignant means of giving voice to those segments of the population that society renders invisible, *Memory* was produced with the assistance of participants in many countries. A soft sculpture, it is actually an assemblage of clothing, joined by means that are not quite quilting, not quite tapestry, to form a massive hanging. Through the phrases embedded in it, *Memory* transformed experiences into a memorial to a moment in time and the human lives it encountered. The words recorded on the surface leave viewers with an impression of the poverty or pain in which those who contributed exist, and in a much more lasting fashion than visual illustration could. Although, as history shows us, mankind has an uncanny knack of ignoring the lessons it ought to learn from empirical experience. How sad it is that Chen Zhen is no longer present to provide these essential reminders.

➤ *Memory,* soft sculpture installation, 300 x 400 x 200 cm, 2000

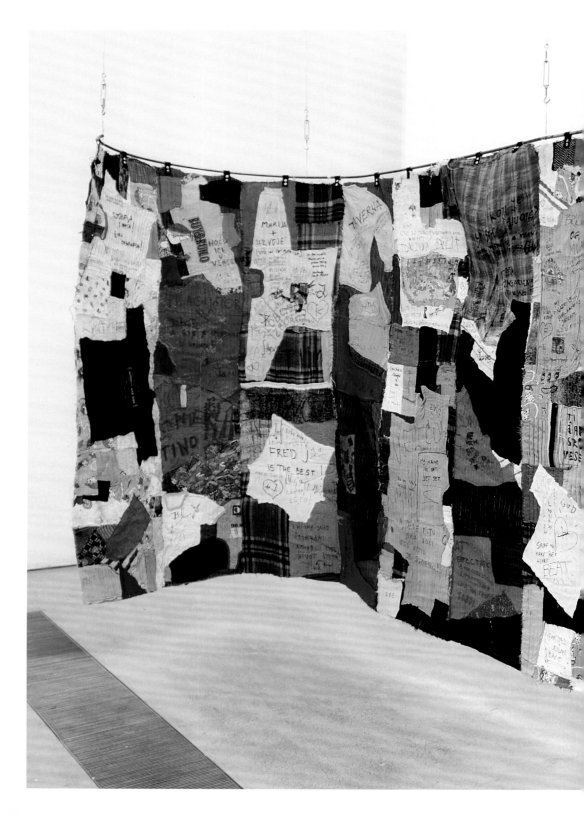

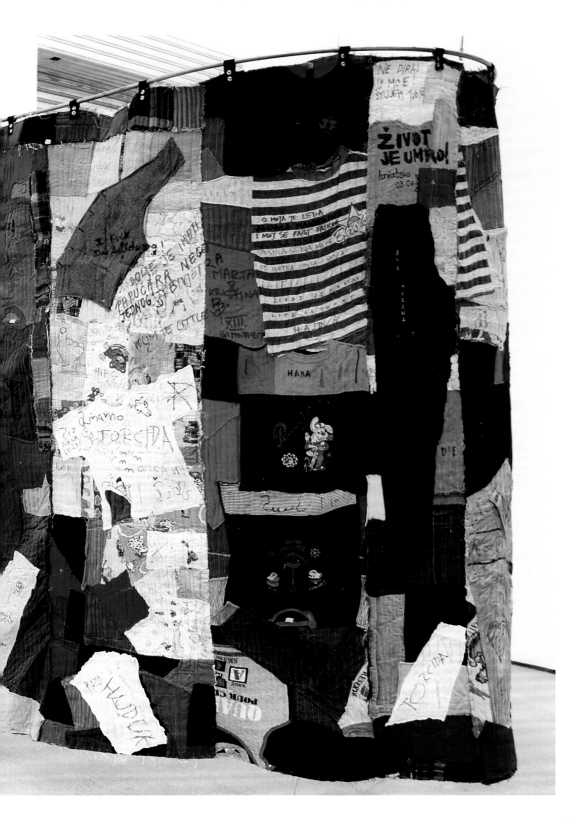

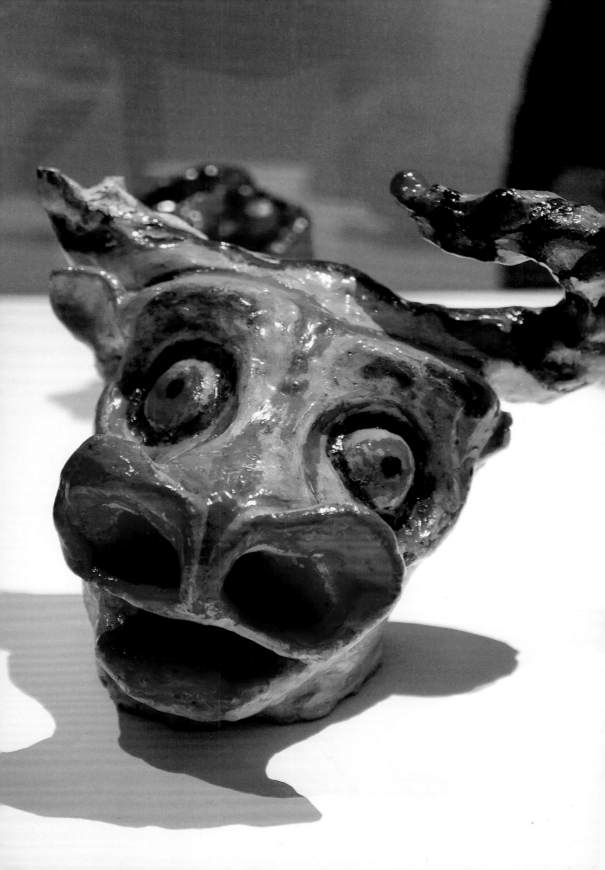

顾德新 | Gu Dexin

Important is not the Meat

Self-taught Gu Dexin (b. 1962; Beijing) was one of the leading artists of his generation. He retired in 2008.

It would have been possible to write an entire book on the works contained in this exhibition; several books actually, for the display of two-dimensional paintings and drawings, as well as the hand-crafted objects that singularise Gu Dexin's early career, merit tomes of their own. The Important Thing is Not the Meat was the artist first and only retrospective exhibition. It revealed Gu Dexin to be a genuine master of artistic innovation, which may seem surprising, perhaps, for those familiar only with his later installations, which comprised volumes of what often appeared to be mundane, old-fashioned children's toys, or piles of rotting fruit and veg. Astonishing, then, to encounter the great volume of early paintings gathered together here, and to experience the full range of styles and approaches used to create them. Neither the pictorial works nor the sculpted objects had been seen together previously, or to such effect. It is not certain that the opportunity will arise again.

Gu Dexin is, was, a retiring, reclusive, avant-garde pioneer, will long be remembered for his large-scale installations: dolls, apples, bananas; masses of them placed together, then left to ripen and rot through the duration of an exhibition, after which the works ceased to exist. Recreated, as they were here, for a retrospective— a concept Gu Dexin viewed as an art-world habit aimed at bolstering commercial ambitions and forging the phenomenon we term "art history"—they were weakened. But even Gu Dexin would have been pleased with the impact of the paintings and objects upon the multitude of visitors that saw them. A wider mode of expression from a single artist is rarely seen—especially from within the art world in China—and, unless this exhibition is resurrected at a future date, will certainly not be seen again from Gu Dexin. In 2008, he elected to give up art and resigned from the art world, politely refusing even to visit this exhibition. It is strange, then, to write about an artist who is alive and well, but who has absented himself from the scene: although this was not the first time

◄ clay sculpture, from a group of 31 pieces produced between 1979 and 1983

▲ *Embroidery A02*, embroidery thread and watercolour on canvas, 52.5 x 74 cm, 1983

➤ *Oil Painting A07*, oil on canvas, 130 x 87 cm, 1983

he withdrew from a path with which he no longer felt an affinity. That first happened in 1995, and precipitated the end of the Xinkedu artist group that he'd formed with the artists Wang Luyan and Chen Shaoping in 1990.

It is partly because the artist is no longer active that the achievement of his early career deserves serious discussion now before it is forgotten. Especially as no other artist of his generation proved so versatile. Not simply unique, Gu Dexin's delightfully diverse body of early work was hugely experimental and wholly unaffected. It began with simple curiosity and resulted in pure innovation. The forms were intuitive, direct and honest. Seeing them in close proximity in the exhibition halls here felt as it must to have entered the atelier of a youthful Picasso just around the time he was moving from the Blue and Rose periods into early Cubism. Similarly, here were early life drawings juxtaposed with the romance of the paintings they inspired. But it was in the collection of objects amassed together, to recreate the world in which Gu Dexin immersed himself in the 1980s, where the use of unadulterated imagination produced pure fantasy in an astonishing range of works.

The display began with small sculptural pieces, primary in colour, with red, yellow, green, blue and pink paint lathered over rough, untreated wood grain. The works all used the same tone of individual colour, thereby suggesting that the sculptures were completed using paint from the same pot and in the same breadth of activity. These were the earliest examples of Gu Dexin's favourite motifs: cows with massive horns;

48

↖ *Wood Board - 08*, oil on wood board, 27 x 38 cm, 1980

← *Wood Board - 11*, oil on wood board, 37 x 37 cm, 1980

↑ *Wood Board - 62*, oil on wood board, 44 x 58 cm, 1981

▲ *Wood Sculpture - 02*, painted, carved wood, 28.5 x 27 cm, 1978-79

surreal, Cubist, almost figures with languid limbs; female forms with a multiplicity of protruding breasts. Gu Dexin also used children's Play-Doh to shape similar forms—animals; birds with fangs; teeth and horns; goggle-eyed and fantastical; the brightness of the colour preserved by a glaze of varnish.

Gu Dexin's earliest oil paintings, landscapes and exterior scenes painted en plein air, suggested in their tentative handling of the medium, a first serious stab at painterly expression. Though dark, the colours were actually rich, again preserved beneath a layer of varnish. Moving into his own world, Gu Dexin painted a man walking a dog against a singularly yellow background, a solitary Picasso-like dove in the sky above. A similarly pale, cornflower-blue composition depicted a female figure with a cat and a bird. He experimented with the shapes of forms, the bulk of a tree, say, and the spirit of the beings portrayed. Most scenes came from Gu Dexin's life. He is the man lying prone on a bed, sick or sleeping, or seated, playing guitar to a flock of cats. Here he had shifted his focus to interiors, his studio—the former apartment home of his two elder sisters—with trees still seen outside a window that would soon become opaque with grime. In this painting, the world inside already felt shut off from that outside.

▲ *Plasticine Figures A01-A64*, plasticine, dimensions variable, 2003

Through the unfolding of time mapped out in the works here, Gu Dexin's progress was swift. In the early 1980s his compositions became momentarily logical—more arty—as evidenced in a series of still lifes; fish on a chair, a skull on a chair, meat, and some kind of fruit, too. There were sober portraits of himself, of his wife, after which his imagination appeared suddenly to break free. By 1984, the works were brighter, as if experiments with Western styles had been dispensed with in favour of Gu Dexin's own fantasy world populated by birds and frogs, cows with their lips pursed, and an aura of love in the air. He produced compositions using fabric dyes, as well as oil paint, which were both delicate and full of light. More delicate still were the childlike embroideries produced in 1983. The simplicity of these images masked a highly sophisticated reduction of natural forms—cows, figures, flowers—to elegant, joyful squiggles.

In the works that followed, Gu Dexin unveiled the perfected version of his trademark figure with its crimson red skin, multiple breasts, and floaty hands on the end of curvy arms. Here, too, he settled on a certain palette of colour: baby blue, crimson, pink and chlorophyll green, which, on occasion, became deeply rich, sultry, sexy and sanguine. Gu Dexin stuck with this repertoire of figure sculptures, computer animations and drawings, devotedly nurturing it year after year, almost to the end of his career. The drawings and paintings tended to become smaller as time went on, the emotions more intimate, but that only made the images more sublime. To imagine a contemporary, light-hearted version of the vision Hieronymus Bosch brought to his *The Garden of Earthly Delights* is to see the world from Gu Dexin's perspective.

From the beginning of the 1990s, as Gu Dexin embarked on his site-specific installations, his main career path was set. Visitors to his home studio would have observed how small-scale experiments with paint and clay continued to occupy his creative hours at home. I'd like to think that, with no one there to observe, they still do.

黄然 | **Huang Ran**

Disruptive Desires, Tranquillity, and the Loss of Lucidity

Based between London and Beijing, Huang Ran (b. 1982; Xichang, Sichuan) graduated from Birmingham Institute of Art and Design in 2004; then from Goldsmiths College, University of London in 2007.

The exhibition Disruptive Desires, Tranquillity, and the Loss of Lucidity consisted of two parts, namely a film, and a separate series of objects. The film, which lent its name to the title of the exhibition, was a breathtaking meditation on innocence and beauty—the suggestion being that the initial awareness of both is the moment when innocence evaporates and is replaced by experience, by knowing. Much like the fall of Adam and Eve, it is this state of knowing that results in the "disruptive desires" that lead to "the loss of lucidity".

The objects exuded a rather more sombre presence, coupled with a hint of trepidation, anxiety even. These objects were a group of Perspex boxes filled with layered volumes of oil and water. The sense of weight contained within the transparent walls emanated a great deal of tension, despite the fact that the oil gave off a golden glow, illuminated by incandescent lighting embedded within. The hydraulic jacks upon which the boxes balanced, and which Huang Ran deployed as elements in and of themselves, reinforced the impression of weightiness present here. Beautiful though these objects were, the unavoidable visual associations with the works of multiple other artists—those who have deployed similar materials and geometric structures to create dissonance in beauty, aura and audience experience—proved distracting. The titles reflected a certain mood of the moment (*The Weakness of Will and the Fear of Society*) and were intriguing in their own way, but it was Huang Ran's film work that stole the show; *Disruptive Desires, Tranquillity, and the Loss of Lucidity* was more alluring than even its title could anticipate.

As a study of human nature, *Disruptive Desires, Tranquillity, and the Loss of Lucidity* was an unequivocal homage to perfection. The two characters at the centre of the film were flawlessly beautiful, and the roles acted out with utter aplomb. The film's faultlessly engineered scenario unfolded in a perfectly designed setting. All the elements within were appropriate to every nuance of the narrative. But the real perfection of

◄ *Love in an Inherent Feeling of Awe and Fear,* acrylic tank, oil, pure water, floor jack, 120 x 120 x 150 cm, 2012

Disruptive Desires, Tranquillity, and the Loss of Lucidity, colour single-channel video, 22', 2012

Huang Ran's vision lay in the deftly intimated tension between the boy-meets-girl protagonists, thrown together in a simple, almost clinical room. Viewers were never fully informed of the nature of their rendezvous, or whether the encounter was incidental or premeditated. The sequence began with the girl adorning a fairground horse, placed in the room, with squares of golden paper. But the focus of every gesture was directed towards illustrating the interaction between the two, as they seem to become aware of each other emotionally, and then physically, as intimation veers towards innuendo.

The film was virtually silent, the only sound being that of rain washing against the window outside as it began, and that of ambient noise in a later metaphorical sequence of "nature", spliced between mutually stolen gazes and exchanged smiles. The use of silent-film techniques—subtitles for words seen spoken but not heard—heightened the focus on every muscle twitch and incremental change in emotion that crossed the characters' faces. As she reached out and unwrapped another candy, placing it in her mouth using her tongue, moistening the paper so it will stick to the surface of the fairground horse upon which he sat, his alertness to her actions became palpable. The boy averted his eyes, as if embarrassed by the thoughts stirring his emotions, his hands evermore tightly gripping the ropes that suspended the horse in midair. The camera panned, skirting over the examination bed in the background, yet reminding viewers

of its presence as it did so. The bottles on a cabinet in the background compounded the sterile atmosphere of the setting—an air of cleanliness that functioned as a quiet reminder of innocence on the verge of being lost.

In terms of the colour in each of the scenes, Huang Ran demonstrated an almost painterly ability to direct the camera lens; it was particularly well attuned to the mood, achieving a realism of fully rounded dimensions, yet obviously constructed. The tone was pastel, from the sap green of the walls, to the cornflower blue of her dress, to the soft ash grey of his jumper. For the viewer, this colour palette was absorbed unconsciously—moment by moment—for, in terms of action, the little drama of awakening was all-engrossing. The actors were as polished in the performance they delivered; the process of mutual attraction felt as real as their initial innocence appeared genuine. The shy, tentative, perfectly nuanced expressions that passed between them contained nothing of the habitual overacting that plagues Chinese cinema. As a flirtation with desire, *Disruptive Desires, Tranquillity, and the Loss of Lucidity* was as perfectly pitched as Thomas Mann's *Death in Venice*, and spoke of similar issues concerning the human fascination with perfect beauty, styled as a lightness of being, which is itself as fleeting as youth.

廖国核 Liao Guohe

Popular Painting

Changsha-based Liao Guohe (b. 1977; Calcutta, India) graduated from the University of California, Santa Barbara, Mechanical Drafting 2001, via Hunan Normal University Art Department.

As I walked into Liao Guohe's solo exhibition I heard people laughing. I assumed I understood why—his work is irreverent in the extreme, in ways that are beguiling, if, at times, sharply lacking in decorum. What they lack in dexterity is more than compensated for with jocularity. That, ultimately, is their charm. For artists, this era is, courtesy of postmodernism, demonstrably lacking in grand theories, yet the creatives keeping the art world buoyant are not without a measure of earnestness about what they do as art. Aligning a mode of artistic expression with one or another theoretical angle, or philosophical thought, is, for artists, a serious issue—even if the intention is to contradict or subvert that angle or thought. In this context, Liao Guohe is an outright rebel. He disdains everything rational about conventional art processes and has no affiliation with style, or "ism", or critical thinking. And yet, at the same time, he reveals—unavoidably, it seems—a faith in the most fundamental function of an image to communicate an idea.

In his work, that faith is visible not just in its choice of formal qualities, which appear primitive in the extreme, but in a sophisticated marriage between image and language—he likes to scrawl text, often phrases that also serve as titles, onto the canvas. At times, this meeting of pictures and words takes the paintings close to being the illustrated butt of a joke. Liao Guohe's paintings can, indeed, be very funny—again, that is usually their charm—but in a style of humour that is also often barbed. His hooks are observations of the society in which he lives, and the all-too-human propensity to be plain dumb in the handling of duties and ambitions. The kind of silliness that is read into, say, *Milk Cow Licking Broken Milk Transportation Truck*, takes on a rather different meaning and weight against knowledge of the tainted-milk scandal that happened in China in 2008 (followed by repeated scares in 2011 and 2012). In this context, if judged

◄ *Fifth Round Thinking about Bananas and Their Rights - Tell a Smartass Chicken Joke to the Party*, acrylic on canvas, 192 x 218 cm, 2011

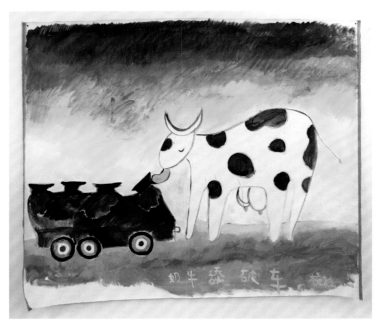

Milk Cow Licking Broken Milk Transportation Truck, acrylic on canvas, 192 x 220 cm, 2011

against a mission to highlight human failings, an encounter with the kind of silliness that Liao Guohe fosters as art is like the throwing open of a window in a stuffy room.

In 2008, when Liao Guohe debuted with a solo exhibition in Shanghai at the Shopping Gallery, visitors were as much puzzled as amused. Not least because he titled it Quietly Appeared Commercial Salon, i.e., Useless King on the Shore of the Fools: Wu Shanzhuan, Wang Xingwei and Liao Guohe Creation Selling Exhibition. To invoke the names of leading artists Wu Shanzhuan and Wang Xingwei parodied modern-day marketing ploys that aim at bolstering sales through associations with fame—not least the blatant reference to "selling"—neither artist was participating in the event. But this strategy was experienced as a blast of fresh air. The works were mad, but full of attitude; silly, but fun in an intelligent manner that by no means took the audience as fools. Behind the wry play on motifs, corny at times, lay real messages. Liao Guohe was playing with painting—with its history, its importance, its life and death—and he was doing so in ways both rock 'n' roll and punk. So, yes, the works looked like children's paintings, as if they could have been done by any amateur, but this type of rhetoric is meaningless today, especially where Liao Guohe's art is such a clear response to the circumstances of its times.

Between that Shanghai debut and 2012, small batches of his paintings appeared in a range of group exhibitions, although not always to great effect; not when placed against other young painters who revel in technique (for most academy trained artists in China paint extremely well) and which, by comparison, Liao Guohe's works can appear overly casual. He prefers acrylic paint to oil, which he daubs, straight out the tube, directly onto pieces of loose canvas, straight off the roll. The results are raw and unpolished,

眼看外星人偷走了香蕉茄子和权利

🔺 *I Saw an Alien Stealing a Banana, an Eggplant and Their Rights*, acrylic on canvas, 186 x 218 cm, 2011

completed in one go, and rarely revised. Small or huge, he prefers not to mount and frame his works, but elects to hang them on the wall in such a fashion that the bottom edge of the canvas curls up in a truly irreverent fashion. This was less obvious in Popular Painting where—unlike in the Shopping Gallery, where they were hung salon style, wall-to-wall, floor-to-ceiling—the variously sized paintings were displayed in a neat line.

Popular Painting was a strong showing with a message that felt powerful, even if, in some of the paintings, it was not immediately clear what that was. This simply invited conjecture—hence the laughter. To call these works paintings, in any traditional sense of the term, is rather overstepping the mark. They have about as much to do with painting as a commercial advertisement does, which is to say there is neither thought nor care for technique, nor for the materials used to achieve it. The title, Popular Painting, offered multiple interpretations, not least, perhaps, an indictment of the mainstream relationship between art and the public. Liao Guohe might well have picked it in the full knowledge that, in China, the form he has chosen for his art is far removed from anything that could be construed as popular. The point is he doesn't care; an attitude reflected again and again in the titling of successive works, such as *I Saw an Alien Stealing a Banana, an Eggplant and their Rights*, or, indeed, *Get Promoted and Make Money!*, not to mention *Hooliganism: A Handbook of Upper-Class Lifestyle*. With these titles, he was exercising his talent for socio-political satire, for humour with a distinctive twist in the presence of an undertone that mocks everything by which the society he knows is governed. Understanding the joke often required a fair knowledge of day-to-day life in China, and yet most of the works transcended the moment of public anxiety that inspired them, simultaneously preserving the mood of the era for future generations.

张慧 Zhang Hui

Groundless

Beijing-based Zhang Hui (b. 1967; Heilongjiang) graduated from the Central Academy of Drama in 1991.

The title of Zhang Hui's 2012 solo exhibition, Groundless, can be explained in relation to the physical "ground" upon which the paintings were created— "ground" being the technical term applied to the layer of base materials used to cover the canvas, which is needed to prepare it for the painting that sits on top. Without a ground—thus in a state we can describe as groundless—paintings are at the mercy of the canvas, be that the neutral tone and weave of thirsty linen, or the bright but volatile warp and weft of cotton duck—both of which, if not sealed by a ground, shrink and move in unpredictable ways that are disastrous to the longevity of a painting.

Groundless was further accounted for in terms of Zhang Hui's choice of black (rather than the customary white base upon which contemporary painting is more usually begun). Yet, looking at the dozen or so paintings the show contained, neither that blackness, nor any visible defects in the surface of the paintings, seemed relevant to understanding the exhibition's theme. That seemed more closely related to Zhang Hui's fascination with the wholly subjective experience of encountering art and of deciding what it might mean.

Zhang Hui did not begin his career as a painter. Rather, he gained his training in theatre design, much like several other notable Chinese artists, and, from the earliest examples of his painting, this grasp of spatial awareness and structure filtered through into the compositions. Experience with the stage and performance has also penetrated his interpretation of narrative in painting. The concept of a prop can become a stand-in for an expressive human gesture. As painted objects, these "gestures" are reduced to emblematic motifs of the kind incorporated into stage sets as graphic notations about the nature of the illusory settings, which the audience instinctively understands. As such, Zhang Hui does not see individual paintings as entirely independent entities. Instead, his concern is of the kind of visual and emotional relationships that they establish with each other and with the world around them.

◄ *Onlookers No.3*, acrylic on canvas, 120 x 100.5 cm, 2011

Relief Sculpture (Listening No.1), acrylic on canvas, 101 x 90 cm, 2011

True to Zhang Hui's signature style, Groundless gathered together an eclectic array of subjects. One group hung in proximity to each other appeared to zoom in, from one canvas to the next, on orange-uniformed workers. First seen from behind, the focus shifted to a close-up of a foot, then the soles of (presumably) the same workman's running shoes. A similar exercise unfolded across a series of patterns in compositions detailing a maze, netting and a game-toy structure. These were almost pure illustrations of the artist's expertise in handling an abstract illusion of theoretical space. One quirky series centred on faultless renderings of old-fashioned lifebuoys made from inflated rubber. None of the subject-objects Zhang Hui portrayed here lent themselves to ready cohesion—not the awning-wrapped trees, nor the unexplained sections of block-like forms caught in the equally puzzling glare of hot white spotlights. The suggestions read

▲ *Relief Sculpture (Listening No.2)*, acrylic on canvas, 162 x 112 cm, 2012

▲ *Dialogue*, acrylic on canvas, 182 x 260 cm, 2011

here are like an essence that evaporates whenever the eye tries too hard to fix it in one form.

The final five images in the exhibition seemed to reference more obviously human situations. *Dialogue* was a double portrait of the artist listening to Gao Shiming—critic, curator, theorist and executive dean at the China Academy of Art—in an animated discussion. The artist carried an expression of glazed bemusement, as if he were assimilating and processing the complexity of thoughts being presented in a dialogue that seems one way. Next to this was *Listening*, a portrait of critic and curator Colin Chinnery—also the curator of Groundless—and then, beside that, was a small painting of an ear, in proximity to two paintings of sculptural busts of familiar art historical archetypes. Due to their side-by-side placing, the busts appeared to be engaged in a private dialogue, perhaps a clue to subjectivity from Zhang Hui's perspective. Sculptures obviously can't talk. They don't hear either. The impression, then, was the question of speaking and listening as being the subject Zhang Hui was exploring here. This was subtly asserted in the careful proximity of this particular group of five paintings. Having examined each one in turn, to then gaze back at *Dialogue*, the expression the artist had given himself in the painting seemed to assume a different aura, aided by the emphatic motion of the critic's hands. Were viewers to imagine that, at times, artists find the theories of critics to be groundless in relation to their own work? After all, critics and

Relief Sculpture (Listening No.3), acrylic on canvas, 121 x 81 cm, 2011

curators are not immune to the subjective whims their experiences encourage.

Subjective conjecture aside, Zhang Hui is a masterful painter. His handling of colour and form is faultless—to wit, the delicious oily rims of rainbow colour that spilled out from the edge of the forms in many of these paintings, as if leaking from inside the objects. Regardless of the substance of the objects in these paintings—concrete block, canvas-wrapped tree, or lifebuoy—each have an oily aura surrounding them. These provide a subtle reminder that paintings are invented images, deployed to relate narratives constructed by the artist in line with an agenda. They will also be seen, contemplated and eventually interpreted in ways that may or may not accord with the artist's original intention. This accords with a process Zhang Hui has described, saying his finished works 'ask me questions', to which he has to respond. And so, in regard of this reading of Groundless, answers to the questions the paintings appeared to pose will presumably be revealed in Zhang Hui's next solo exhibition.

谢帆 | Xie Fan

The Layers

Beijing-based Xie Fan (b. 1983; Jiangyou, Sichuan) graduated from the Sichuan Fine Arts Institute in 2005.

Painter Xie Fan produces paintings that are almost photographic in the degree of realism they possess. He works with diluted layers of oil paint of a severely restricted colour palette. A distinguishing feature is the choice of surface to which the paint is applied. As a substitution for canvas, he prefers the Chinese silk known as *juan*, often chosen for the finely detailed gongbi style of ink painting, as opposed to the more impulsive *xieyi* work done on xuan rice paper. The palette range is controlled within specific monitors, such as being as pale as the clouds the paint is used to depict— of a state of whiteness given volume by gentle hints of grey that give depth and form to a vaporous mass. Equally, Xie Fan uses chlorophyll greens; brilliant as if under a summer sun, darker as if day has fallen or the season has shifted. A similar effect is achieved with fine variations of blue: deep like midnight or bright like a clear autumnal sky. On occasion, Xie Fan drains the colour from a scene entirely, preferring a straight monochromatic blend of grey and white, which is neither charcoal dark, nor pure titanium white.

The whole approach is subtle and, as the title of the exhibition suggested, about building layers of paint to represent the physical stratum of a vista from the natural world—layers that construct depth of field and combine to form an illusion of reality on the picture plane. "Layers", too, because working on juan requires a delicate, controlled handling of the pigment. In terms of technique, painting on this type of material is completely different to canvas. *Juan* is like gauze: tough, but also fragile. The weave of the fabric is as fine as the threads used to construct it—but gossamer fine, as they are, they demand a lightness of touch if the colour is to sit on the surface and not bleed out into irredeemable pools of mud. *Juan* is easily clogged with paint; impossible to scrape clean to begin afresh. For Xie Fan, the semi-transparent quality of *juan* is the point of using it. If that transparency is lost then the material itself is redundant. Thus, to maintain the material's integrity, it is necessary to build up layers in careful, painstaking

◄ *Mountain* (detail), oil on silk (*juan*), 100 x 100 cm, 2012

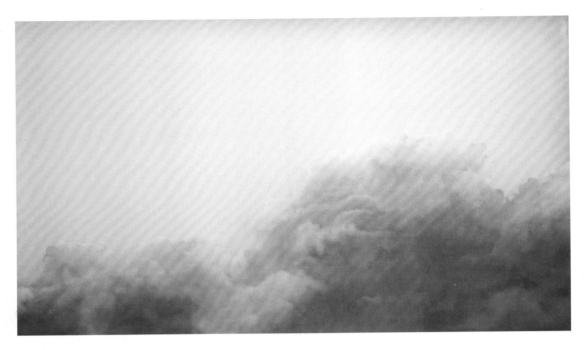

▲ *Cloud*, oil on silk (*juan*), 120 x 200 cm, 2012

fashion, which was well evidenced by the technique Xie Fan has developed in the paintings displayed here.

The scenes of nature Xie Fan presented were not broad in their variation. They focused on specific elements—a pathway through dense vegetation; a road; a cloud; a tree or clump of foliage—in what might be an allusion to traditional uses of objects and elements of nature in Chinese landscape painting. The paintings had a similarly escapist air, too, as a contemplative space for the imagination, each scene airy and inviting, if, at times, brooding more than lighthearted. These were not realistic spaces in the sense of Western landscape painting—more Turner than Gainsborough for sure, and with a good measure of the air of the style made famous by sixteenth-century Japanese painter Hasegawa Tōhaku (himself inspired by ancient Chinese painting techniques). Yet, overall, Xie Fan seemed to be closer in spirit to the German painter Gerhard Richter than to the Chinese idiom. Xie Fan's painting differs in several respects from the order of painting in recent years in China. There is nothing cynical in his work, no tongue-in-cheek play with motif, but, instead, a clean and fresh approach, which stems from a genuine concern to forge a distinctive style. The use of oil on *juan* may not automatically suggest a new mode of working, but, in the photographic attention to detail, the results suggest a mastery of technique, not for its sake alone, but to transcend it such that the artist is able to control

▲ *Tree: Blue,* oil on silk (*juan*), 90 x 160 cm, 2012

the message completely—effortlessly. The greenness of tones, the blues, and even the pale luminosity of the sky, feel alive, nutritious.

So what might the message be? In the conscious reference to the constructs of nature as art, there was a cinematic framing of the scenes, which felt metaphoric to the point of appearing portentous. The use of layers to structure the scene, giving density to leaves, foliage or cloud, transcended the subject to become poetic—a technique refined within Chinese culture ever since a landscape tradition in painting was established here in the fourth century (as compared with the later arrival of the genre in sixteenth-century Europe). While clearly modern in aura, The Layers bestowed an echo of lines written by the celebrated Tang-dynasty poet Wang Wei (699-759): '*A narrow, sunless path to the temple tree / Deep and dark; abundant green moss / Wait by the gate when finished sweeping the yard / In case a monk should come down from the hill.*' Or, equally: '*The autumn hill gathers remaining light / A flying bird chases its companion before / The green colour is momentarily bright / Sunset mist has no fixed place.*'

In the chemical tint to the tones, green in particular, a soothing suggestion of verdant life was denied. Instead, the paintings were a reminder of the man-made aspect of the natural environment in the modern age, and, that this was art after all. All painting necessarily works under the paradigm of acceptable deception; here, with The Layers, Xie Fan found an interesting response to the question of what painting can be today.

王
度

Wang Du

Contemporary Art Museum of China

Paris-based Wang Du (b. 1956; Wuhan, Hubei) studied at Guangzhou Academy of Fine Arts, and founded the Southern Artists' Salon before moving to Paris in 1990.

Wang Du has spent the greater part of his artistic career living and working in France. Even prior to arriving there, the focus of his art was tightly interwoven with the daily unfolding of sociopolitical events. In France, these responses were broadened by his exposure to world events, and transposed into often monumental sculptural installations in the form of figurative interpretations of leading international events, as well as the dominant domestic headlines in France, as presented through the narrative of the mainstream media.

From the first, Wang Du's version of events—characterised by the scale he applied to individual components to match either media endorsement, the weight of public opinion, or degree of fame and notoriety—challenged or called into question "truth" as the guiding principle under which the media operates. It is not about providing alternative truths, or other specific versions of events, but highlighting the varying shades of truth by which any event can be—is—elucidated. Wang Du's approach uniformly weaves a healthy dose of humour into these reflected fabrications. All these qualities were out in force in the monster form Wang Du presented in early 2012 as his take on a *Contemporary Art Museum of China*.

China's rise in the last decade has been nothing short of astonishing. Everything about the nation has been big, of a scale that most Europeans find hard to grasp, and which even Americans, who have not visited, find hard to imagine. The numbers that describe any demographic or developmental project are huge, but ultimately meaningless out of context. It is the scale that counts, and which *Contemporary Art Museum of China* captured so well. Continuing the "China Dream" of acquiring all that the West has, and more, of going beyond achievements in all developed nations, to excel in every sector, *Contemporary Art Museum of China* encapsulated the nation's cultural ambitions of owning the greatest museum on Earth.

◄ *Contemporary Art Museum of China* (detail), installation work, iron, 10 x 6 x 2.8 m, 2012

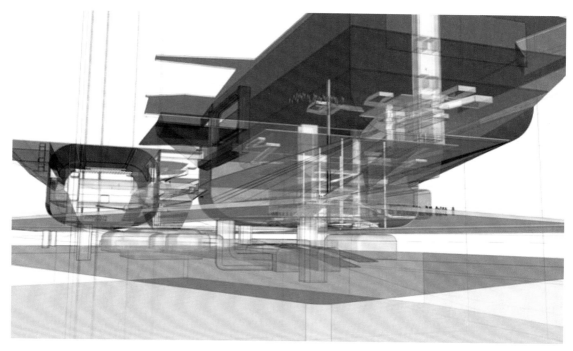

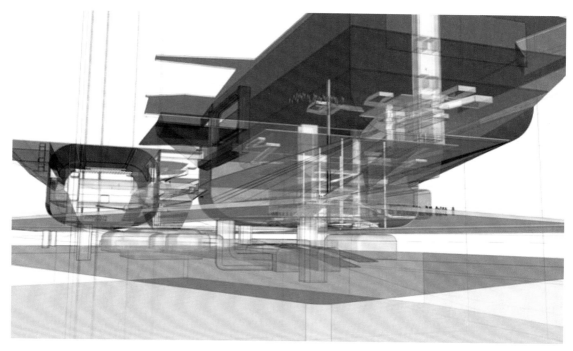 detail of animated computer design walk-through

The form and structure of Wang Du's *Contemporary Art Museum of China* was suitably adaptive, appropriating elements of London's Tate Modern, New York's MoMA and the Pompidou Centre in Paris, which were expanded upon and conjoined to arrive at a building approximating the expectations of China's artistic community and its leaders. As the new Power Station of Art, Shanghai's government-backed gallery (measuring 15,000 square metres), prepared to open its doors to host the ninth Shanghai Biennale, the name of the nominated architect for the capital's equivalent— a new 1.3-million-square-foot National Art Museum of China (NAMOC), slated to be the most 'symbolically important cultural building' in the country—was released at the end of 2012, thereby allowing work on the construction to begin. Here, *Contemporary Art Museum of China* proved itself to be right on the pulse of the moment.

Anyone unfamiliar with Wang Du's style of artwork might have read his *Contemporary Art Museum of China* model as the proposal of an artist who clearly shared the aspirations of his Chinese countrymen. While knowledge of the wit he injects into art may cast some doubt as to the extent of those ambitions, *Contemporary Art Museum of China* was clearly more tongue-in-cheek than biting satire. Possibly, the reason he paid such extraordinary attention to the details of the model, not only in terms of its design and concept, but in light of the work and planning concept evidenced in the 3D walk-through animation that accompanied the installation, visitors might easily have been duped into thinking *Contemporary Art Museum of China* was Wang Du's audition for the job.

$\cdot \rightarrow \text{\texticon} \rightarrow \cdot$

关于《地书》
ABOUT
BOOK FROM
THE GROUND

徐冰 | Xu Bing

Book from the Ground

Beijing-based Xu Bing (b. 1955; Chongqing) graduated from the Central Academy of Fine Arts in 1987.

Xu Bing was propelled into the limelight in 1988 following the response to his first "book", *Book from the Sky*, at its debut at the China Art Gallery—now known as the National Art Museum of China—as part of a rare showing of the work of aspiring modern Chinese artists in the nation's leading art museum. In that moment, Xu Bing was one of just two artists to be granted that privilege. But it was not just the stage upon which *Book from the Sky* was presented that caused the sensation: it was the manner of its presentation. Xu Bing chose the form of an installation at a time when the word had almost no meaning in the field of art in China. The "book" was draped from rafter to rafter, in elegant arcs of unbound pages, which swooped almost from the ceiling down to the ground beneath.

To that point in 1988, *Book from the Sky* had taken almost four years to produce, and would require one more in order to complete the full complement of four thousand reconfigured Chinese characters, which Xu Bing had first "invented", then hand carved on wooden blocks, before printing as text in his book. The sensational impact of these characters, flowing across the unbroken skeins of paper that formed its uncut pages, ultimately immortalised the work, as an element of debate ensued. That there are ways to communicate beyond readable linguistic structures became a guiding principle of Xu Bing's work; a holy grail, almost. Arguably, in 2012, with *Book from the Ground*, he found it.

More than two decades on, upon its unveiling in Shanghai, *Book from the Ground* caused just marginally less of a sensation than 1988's *Book from the Sky*. For reasons of its contemporary, youthful vocabulary, *Book from the Ground* has a broader appeal than Xu Bing's first *pièce de résistance*, and was an instant hit among technology savvy viewers—at least, everyone who uses social networking applications as their main means of communication. Circa the mid-1980s, as China approached a decade of reforms, *Book from the Sky* was a reflection upon words, text and the

◄ *Book from the Ground*, book and catalogue cover

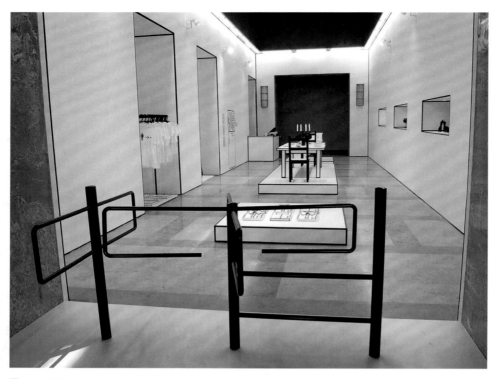

installation view

meaning of language within the immediate cultural framework. In the same way, *Book from the Ground*, with its iconographic shorthand, is a project for the modern age, predicated on shorthand symbols of information exchange.

As nations and cultures worldwide link in to the travel and business network of the global village, an international, almost universal language of communication for basic utilitarian needs has evolved to accommodate us in any land as we shuttle from country to country, city to city. Symbols have long been a part of modern life—think of road signs, exit signs in buildings, safety manuals on planes, and even those courteous hints on public transport to give up seats to those in need—but so ubiquitous has the prevalence of these icons become today that they barely register as the phenomenon they are in every aspect of contemporary life.

From the early 1990s, as an international artist based in New York, Xu Bing spent a great deal of time travelling between museums for site visits and to install his works. He used to say he liked it: it gave him time to think and to work in peace. It was also exhausting, and between moments of stasis as he navigated his journeys, he began to notice the proliferation of symbols in those zones in which people spoke every language imaginable, but needed instant signposts to guide them on their way. That was 2000. Two years later, Xu Bing had amassed a large collection of signs preserved in an expanding volume of notebooks. This was his research for a counterpoint to *Book*

from the Sky. Instead of obscuring language by altering characters, he would write a book with no obvious language at all, just signs.

Fast-forward to 2012, when the fruits of his labour gave birth to a book—the first progeny of *Book from the Ground*—written entirely using icons. The story is obvious to anyone who communicates via technology on a regular basis. Some may require a bit more time and thought to follow the protagonist through a "day in the life" narrated by the steady stream of pictograms, but it's amazing to realise how many symbols exist to express actions, emotions and objects. It is a language that we are in the process of acquiring by osmosis, without even realising how fluent we are.

The core of the *Book from the Ground* concept was communication relevant to the changing linguistic needs of the world we live it. The first manifestation was a communication system with which visitors could interact using a computer and projector arrangement installed in an art space. That was part of this exhibition, present as a large studio area where visitors could see how signs had been collected "from the ground", mapped and inserted into Xu Bing's "pictographic" book. The reference to pictograms as the earliest form of writing, from Egyptian hieroglyphs to ancient Chinese characters, was important, for Xu Bing sees this modern-day pictography as a return to the very origins of linguistic communication.

As the project developed, it expanded in various directions. On the technical side, the artist continues to work on a word bank and functional typing system. One particular section of this exhibition took the viewer into a virtual world, entirely black and white in nature, where neither the space, nor the object within it, had any obvious depth or dimension. Attractive as it was, it seemed to hint at what might be lost if we reduce everything in life to a simple cipher.

Irrelevant Commission

无关小组

Why We Do Useless Things? and Unrelated Parades

Multi-membered Irrelevant Commission (b. 2011; Hangzhou, Zhejiang) generally graduated from the China Academy of Fine Arts in Hangzhou around 2008.

Irrelevant Commission is one of a number of artist groups operating in China at present. Since its inauguration, its activities have been particularly effective in the field of performance, although, as the group's manifesto is quick to point out, the "action events" that Irrelevant Commission orchestrates are not 'performing in order to be performed', but are vehicles for communicating an idea or attitude. Why Do We Do Useless Things? was the title of the group's first exhibition event that took place in the spring of 2012, and firmly placed the onus on a collaborative approach to creativity, each member pitching in to produce a group of installation works. Ahead of the project, the nine official members of Irrelevant Commission returned home to visit their families with the specific goal of addressing—confessing, almost—what it is that they do as artists in the contemporary art field, and eliciting a response from their families. In the China context this was more radical than it sounds because most artists prefer to keep their parents in the dark.

So, while the project sounds simplistic, in China, it touched upon the changing role of art and artists within society: a legitimization, if you will, that is unravelling the mystery about what non-traditional art can be, especially at the experimental end of the spectrum. As a project, Why Do We Do Useless Things? was intended to capitalize on this momentum and draw ordinary people, in this case empathetic relatives, into the arena for discussion. Just as I remember as a child hearing family debates about Tate's decision to collect twelve bricks by American minimalist Carl Andre—opinions ranged from ridicule to outrage—the raison d'être of much modern art remains, for many people, a mystery. Why Do We Do Useless Things? determined to use the information and sensibilities that emerged from the familial exchange of ideas to create a series of works for the exhibition and, thereby, to bring the discussion into the public arena.

It was not necessary to be fully acquainted with the project's backstory to enjoy Why Do We Do Useless Things? As an exhibition, it was clearly a fresh approach

◀ *Centipede*, household items, dimensions variable, 2012

🔺 *The Parade Project 1: Look Right*, performance, 2011 -- on-going

to reflecting the cultural status quo in China. Where the artists attempted to respond to the specific environments of their families, works in the exhibition incorporated a liberal volume of ordinary objects reconfigured with demonstrable panache. Agricultural implements dipped in white paint were adorned with delicate line drawings. Old-fashioned table lamps were clustered together to form a grand chandelier. Common red bricks were taken as sculptural elements to structure a shrine-like altar.

On the second floor, a number of very ordinary doors, which appeared to have been plucked directly from their home environment, were joined together and hung from the ceiling in an unbroken chain of "closedness". This piece was accompanied by photographs showing the original locations of the doors, and was further juxtaposed with videos detailing the individual group members discussing their art with their respective families. As an exhibition, Why Do We Do Useless Things? was as charming as its title, and, with appropriate contemporary irony, comprised of art that was very much from the masses, for the masses.

This was followed towards the middle of the year by *Unrelated to Parading*. This show brought together a number of video works, which represented recordings of the group's 'performing-not-in-order-to-be-performed' activities, carried out between April and June. These were presented along with a gloriously spontaneous *Centipede*, assembled from an array of brightly coloured plastic buckets and basins, speared by bendy tubes and pipes. Although the group claimed that the centipede's primary

▲ *The Parade Project 3: Railing*, performance, 2011 -- on-going

role was to fill the space, it was a fine and fun addition to the more thought-provoking content of the video works.

The reference to parading centred on a series of what appeared to be choreographed actions carried out by Irrelevant Commission—specifically at various art-related sites in the capital. In these videos, the group could be seen marching in slow-motion unison through Beijing's 798 art district, joined by a large and enthusiastic crowd of volunteers. Those in the front row, and at either end on each side, held a section of white railing, of the kind usually deployed in crowd control; since they were within the barriers, they were the ones being controlled. On the next screen, a slightly reduced version of the group was engaged in a synchronised stroll around the booths at the China International Gallery Exposition, weaving between visitors.

Replayed in the gallery as video recordings of the events, Irrelevant Commission's parading looked like a huge amount of fun, if slightly menacing as a disruptive element in the context of an art fair. But behind all the action performances was a serious message, which the group has described thus: 'The idea of parading comes from the action of a strike. To strike is to seek to display dissatisfaction with a certain system; its purpose is to challenge they system, to effect change. We are obviously not going on strike per se, but parading is, for the group, the next best thing.' Because these actions are open to public participation, Irrelevant Commission's art and ethos are, in fact, more than relevant to the art-loving public.

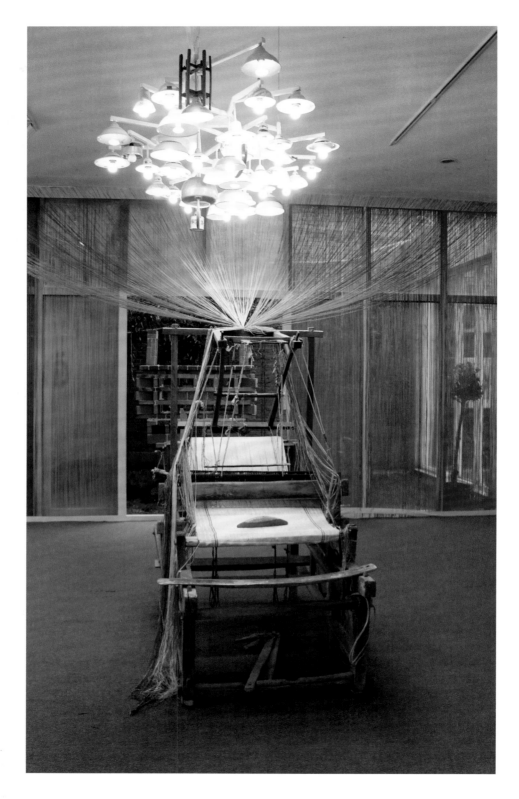

↑ *Relevant to Families* (detail), tools, rice paper, 2012

◄ Why We Do Useless Things (*Relevant to Families*), installation view, 2012

It is useful to explain how the group chose its name. In Chinese, the phrase *wu guan* more closely means "unrelated to anything; different from anything". Irrelevant Commission is certainly different. The group's work is amusing, but to say that much of what they do as art is light-hearted fun would be to oversimplify it and miss the brilliant absurdity of their activities. Whether parading or constructing an installation assemblage, as the riotous snake of household objects that comprised *Centipede,* collaboration as a group functions as a platform for understanding social interaction, even if within the boundaries of the relationships that exist amongst the group's members: The difference between a group and an individual is that, as a group, we individuals have more force; more power and courage. There is always a degree of conflict between the group's members: if there is a disagreement that it is up to the one who disagrees to persuade the others to his or her opinion. We tried democratic methods, such as show of hands, but it didn't work, so we had to abandon it.' Thus, here, what these young artists absorb through their activities has a transformative effect. Irrelevant Commission is thus far more relevant that its title pretends.

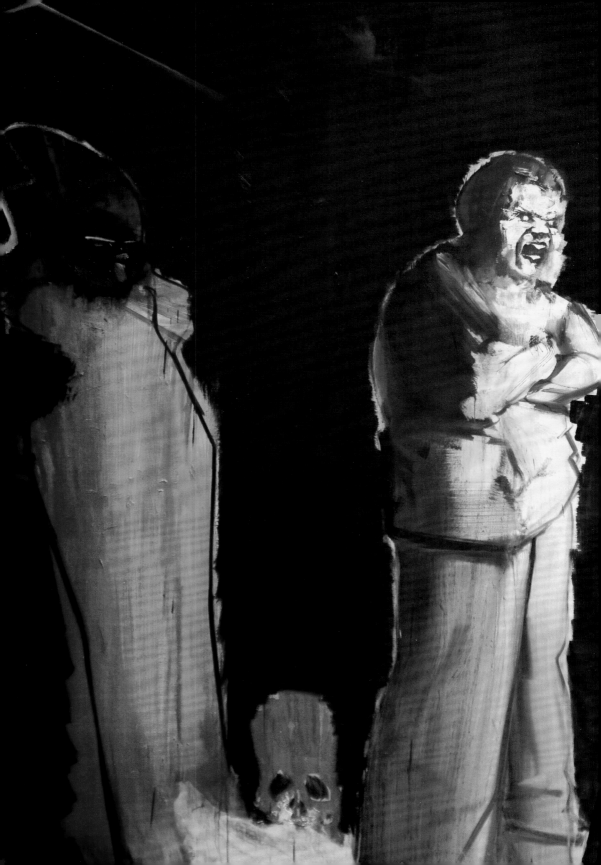

马 轲

Ma Ke

Life Most Intense

Beijing-based painter Ma Ke (b. 1970; Shandong) graduated from the Tianjin Art Academy in 1994, and with an MA from the Central Academy of Fine Arts in 2004.

Life Most Intense was an exhibition I curated for an artist that I had first met barely a year before. Nevertheless, he had been painting for himself for more than a dozen years. Further, since completing his MA in 2004, Ma Ke had had more than enough time to develop his style and refine his focus. His paintings were mature, their subject and impact astonishing, and not merely because the artist was passionate about painting in a way rarely seen in China—although it is perhaps fairer to say passionate in a way that has not been *fashionable* in more than a decade (for reasons aligned with the interaction between art circles in China and the West, and of the urgent and nonlinear approach that has evolved to conveying a contemporary position). Ma Ke's contrary attitude, an obsessive interest in the substance of paint and the drama of the illusory reality that paintings present, placed a veil over his presence in the contemporary arena in China. At the same time, where his style drew the favour and support of a number of collectors and followers who provided for his needs, a further distance between artist and public was ensured. For the artist, then, Life Most Intense was a significant introduction of his work: a presentation of approximately thirty paintings that Ma Ke had created in the preceding years (from 2009 to 2012).

To have an exhibition time frame as deadline was cathartic. Ma Ke had previously produced a number of large works, but was now encouraged to expand both the scale of the paintings and the cast of characters depicted. Visually, both the men and women in his works had evolved a particular physical body type, which was squat and thick, in the same way that the term "big-boned" is applied. Oddly proportioned and habitually painted in a standing posture—a choice aligned with the artist's flair for theatrical drama—the figures appeared distorted, as if by a camera lens, or as the reflection in a body-bending mirror. Ma Ke confided that neither the female figures in the compositions, nor their male counterparts, were intended to reference fixed gender types, nor was their collective physical attitude transposed from an actual real-life

◄ *Who Will Gain Supremacy*, oil on canvas, 254 x 200 cm, 2012

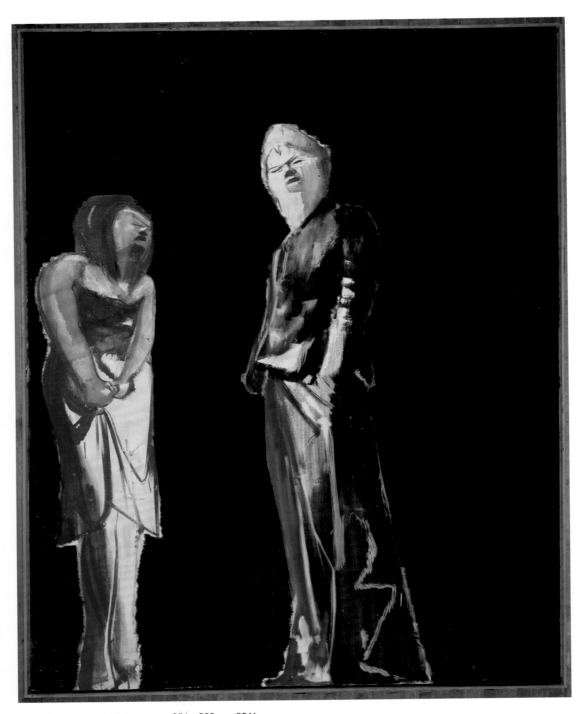

▲ *Open Sky,* oil on canvas, 254 x 200 cm, 2011

model. They were, instead, each an expression of himself, or of an aspect of human nature he found fascinating; a way of achieving an anatomical presence that expressed the nuances of human interaction he was exploring. With a group of paintings gathered together for exhibition, it was clear that a great deal of that fascination seemed to lie on the darker side of those qualities we recognise as human.

The figures—it was Ma Ke's figure paintings that were the specific subject of Life Most Intense—were, more often than not, presented on their own, or in male-female binary couplings, always with an edge of unspoken anxiety, tension or despair filling the spaces between them. Often, these particular pairings were awarded a dark background, almost entirely black, out of which the players emerged like actors on a minimalist stage—see, for example, Open Sky, Love Story of the Empire, or Who Will Gain Supremacy—in the midst of an assumed tragedy directed by the hands of an unseen power concealed in the black depths above. Similarly, the lone male figures were imbued with a common aura of insecurity, largely precipitated by the uncommon articles they held, as well as the actions in which they appeared to be engaged. For those compositions containing the single figure of a woman, the aura was lighter, more tentative perhaps for being soaked in what can be described as a feminine palette of colour. Together these components managed to insinuate a sense of vulnerability within the condition of these women. Nonetheless, their expressions were as easily read as anguish as they were nonchalance, or simply a moment's daydreaming.

Both men and women were often shown with their hands clasped together before them, a pictorial device that, along with the physical form and hunched posture of many of the figures, was repeated across numerous paintings. Seen again and again, the effect was to suggest the kind of handwringing that augurs no good—think of the figure of Mr Micawber in Charles Dickens's David Copperfield, say, or Lu Xun's titular character Ah Q. Ma Ke's view of humanity here appeared to be somewhat perplexed, whether that be by its qualities of evil, weakness or vulnerability—or of its propensity to be led astray or to instigate violence. As a result, the paintings achieved a powerful impact. They had a certain magnificence about them that arose from the mix of fascination and repulsion that viewers experienced in their presence. But even at their most extreme, where the content or the nature of the subject matter seemed to stray into unsavoury emotional states, the physical quality of the paint on Ma Ke's canvases was an unerringly redeeming factor.

▲ Life Most Intense, installation view: *Youth 2*, oil on canvas, 150 x 200 cm, 2010 (left);
Theatre, oil on canvas, 200 x 200 cm, 2012 (right)

蒋志

Jiang Zhi

If This is a Man / 5

Beijing-based Jiang Zhi (b. 1971; Yuanjiang, Hunan) graduated from the China Academy of Fine Arts, 1995.

In recent years, through various forms and media in art, Jiang Zhi has explored loss and the unfolding of grief. That unfolding happens in stages, beginning with anguish and hurt—and the inability to comprehend absence—transitioning through anger, before arriving at a point where the emotions are at the final stage of being able to let go. It is possible to trace this exploration back to 2009. An early illustration of unfolding emotions is found in the video work Jiang Zhi titled *0.7% Salt*, which, in the vein of a method-acting class, showed the face of a beautiful young woman moving through every imaginable nuance of human emotion—from pleasure to pain, laughter to tears.

A more recent and subtle example came in the form of the artist's Araki-style photographic series of glorious, rare, floral blooms—orchids mainly—each fanned by a plume of flame that could only have come from petrol, or lighter fuel, sprayed on the petals before being ignited. It was the glow of otherworldly blue luminosity that was caught here on film (before any real damage to the bloom became visible). Jiang Zhi called the series Love Letters, but, whether due to a voluntary will of self, or inflicted by an external force, no amount of natural beauty—of which the blooms were in ample possession—could overcome the aura of cruelty that these works radiated. The sense of willful destruction merely paralleled a commensurate sense of the injustice of loss.

If This is a Man, Jiang Zhi's solo exhibition in Guangzhou, made curious reference to Primo Levi's book of the same title, which has been described as a quest for 'humanity in the midst of inhumanity' through his account of his detention in Auschwitz in 1944. Whether conscious of this issue of (in)humanity or not, the exhibition put all these emotional states as explored in relevant examples of his works into the context of his career. It was, thus, an attempt to examine the man as an artist, as a humanist, in the broadest sense of the word. As such, it did well to explore the various artistic identities Jiang Zhi has developed throughout his career, including photography, video, painting and curating. With its retrospective aspect, the exhibition

◄ *5, colour single-channel video, 74' 16", 2012*

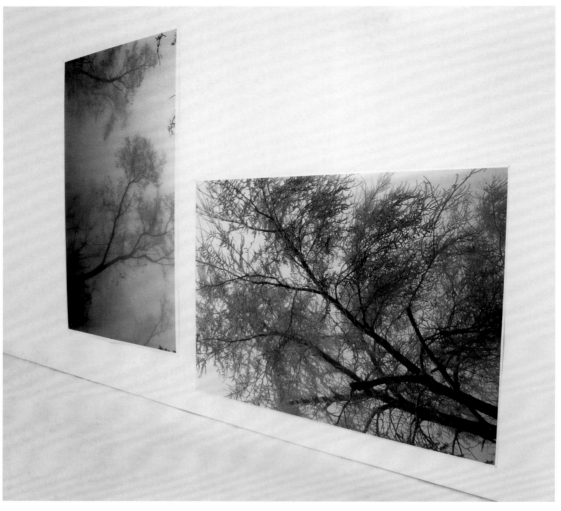

If This is a Man: installation view of *Landscape of the Very Spirit*, black and white photos, various dimensions, 2008-12

was clearly a pause for reflection in a career that now spans almost fifteen years. And so Jiang Zhi included an overview of earlier works, a number of which had not been widely seen before.

One of these was a series of photoworks he produced from the late 1990s, in a succession of locations, which centred on the imaginary figure of "Mu Mu", a tiny peg-doll figure that the artist placed in a variety of settings to imitate photographic conventions. Here, they were used to turn the tables on the audience, inviting visitors to create their own "Mu Mu-style fiction", which they could then submit to the museum for display. The rest of the exhibition was divided into several sections, including *Landscape of the Very Spirit*, a particularly beautiful, ethereal group of black and white photographs on the theme of nature. Through his poetic framing of the scenes,

▲ If This is a Man: installation view of *The Man with the Eye-White*, various oil paintings

they captured and echoed Jiang Zhi's literary skills, the poet in his nature. He also demonstrated his curatorial side with a nice selection of paintings by Xiong Wangzhou (a fellow artist from his hometown).

It all worked extremely well in the context of this show, and in the context of an intellectual exercise, which is to say an examination of the function of a retrospective, and its relationship with an artist's development. And, in theory, as a means of challenging the singular role of "artist" as being that of someone who simply makes art, where Jiang Zhi steps over boundaries—be they literary or curatorial—as many artists in the field today are inclined to do. This exhibition, then, adopted a specifically cerebral line of enquiry about the multiple facets of artistic practice.

That only made the experience of *5*, shown in Beijing later in July, all the more striking. In this compelling video work, Jiang Zhi went straight to the heart of his subject matter, inviting viewers on a naked emotional journey via the experience of watching, from beginning to end, what was a full feature-length sequence (with a running time of 74 minutes). It was not entirely necessary to watch *5* from start to finish to experience

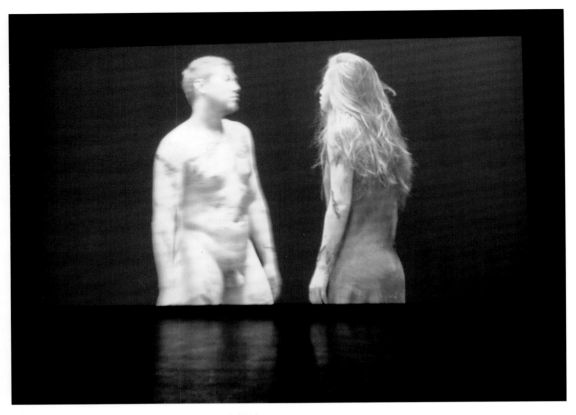

5, colour single-channel video, 74' 16", 2012

the work fully, but it certainly deepened the admiration for Jiang Zhi's achievement: the performance seen here was shot in five long segments; so that no sequence of the emotional sequence that actors presented was repeated through editing.

The work focused on the interaction of a young man and woman, dancers, in fact, whose steps were choreographed to arrive at the same denouement over and over again. Cast in the role of lovers, the performance followed a similar unfolding as explored in Jiang Zhi's *0.7% Salt*—the full range of human emotion brought to the phenomenon we term love. The pair thus acknowledged each other as if upon a first, incidental encounter. Experiencing a mutual attraction, they became drawn to each other. Gently, sensually, they touched, and, in becoming joined, the atmosphere of the film became charged with an almost sexual energy.

They kissed; they embraced; there was a tightening of limbs, at which point viewers experienced a wave of impending voyeurism. But then, suddenly, shockingly, one of the two broke free, rejecting the other in a violent display of anger or disgust. As

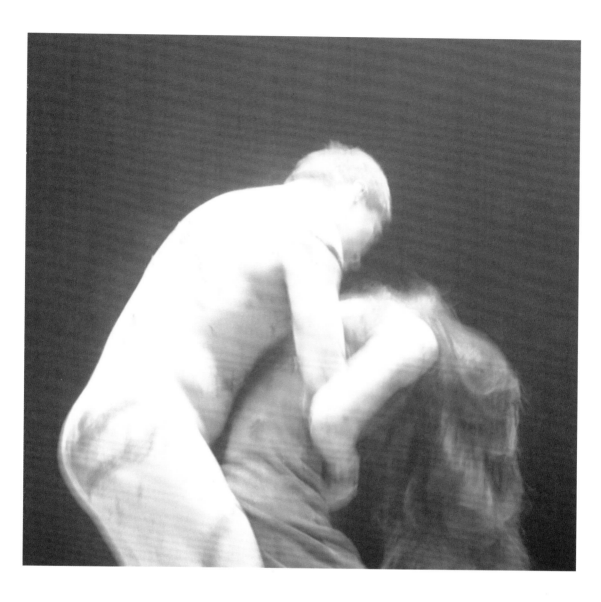

the video work unfolded, this anger alternated with a pouting, sulking withdrawal, testing the full force of the love which, if not adequately requite resulted in dissolute expressions of betrayal. And so the work unfolded in a cyclical round of angry dissonance and hungry desire—that which binds lovers together, and directs the ways, and means, they deploy as tests of that bond. In terms of the artist's exploration of loss and human emotion, 5 embodied a spirit of resurrection; for the artist, a powerful return to life.

杨福东 | Yang Fudong

Close to the Sea / Revival of the Snake

Shanghai-based Yang Fudong (b. 1971; Beijing) graduated from the China Academy of Fine Arts in Hangzhou in 1995.

It took Yang Fudong half a dozen years, from 2003 to 2008, to complete *Seven Intellectuals in Bamboo Forest*, a five-part film cycle. During that time, his mind and eye were focused on interpreting the worldview of China's youth. This exploration was presented in black and white, using a visual, metaphorical vocabulary associated with Shanghai and the energy of the New Culture Movement, which had taken place almost exactly a century earlier. This artist's work was, for a period of time, confined to a singular path—one that proved so successful that the series ended up temporarily eclipsing other aspects of his rather varied cinematic vision. The screening in Beijing of two earlier works—*Close to the Sea* from 2004, and *The Revival of the Snake* from 2005 (both, somewhat amazingly, being shown in China for the first time) —was a timely reminder of his other achievements and range.

The ten-channel work *The Revival of the Snake* is most recognisable for the famous frame it contains of a young soldier in a tree, which was used as the catalogue cover image for Yang Fudong's solo exhibition at the Castello di Rivoli Museo d'Arte Contemporanea in 2005. A beautiful image, it is somewhat unrepresentative of the work, which pivots on the fatalistic story of a soldier's desertion from his army battalion; contrary to the blue-sky photograph, the film itself is suffused by an aura that is grim, forlorn and melancholy. The emotional results of combat experiences, and the complex psychological state of a soldier, are topical tales for this era of almost constant invasion (and the occupation of what turn into bitterly entrenched war zones). Thanks to Hollywood, as much as the wider media, the drama of war, especially for the solider, has become a pervasive force in the collective consciousness of recent human experience.

Yang Fudong captured his soldier-protagonist in a perpetual state of slow and measured motion. The scene in the tree, and those in the night, provided the only pauses. During the latter, he was shown lighting a fire, under the cover of darkness,

◀ *The Revival of the Snake*, colour ten-channel video installation, 8', dimensions variable, 2005

▲ *Close to the Sea*, colour ten-channel video installation, 23' , 2004

to prepare what was less than a meal, not more than a morsel, in an attempt to fill his empty stomach. This act of meagre consumption seemed to parallel the internal emptiness that drove the soldier to desert. In a deft juxtaposition of scenes, and to extend the span of cinematic time, Yang Fudong presented the solider as being both young and old at once, his journey to be read as one of a lifetime. The boy in the tree represented the soldier as an adolescent.

In his older form, the descent into age was characterised by the tattered quality of his clothing—an old-fashioned uniform consisting of a mix and match of World War One and Eighth Route Army garments—and the wounds he appeared to have sustained, thereby signalling his arrival as an everyman soldier. His wounds were physical as well as metaphysical—intended to serve as a reminder of the horrors of war. Blindness was conveyed by the bandages covering his eyes: a metaphor for concealment; a reminder of what the soldier wished he had not been made to see. The loss of vision also suggested how valiant young men go blindly into battle, never adequately prepared for the horrors that war entails.

Across the ten screens, the soldier moved through landscapes that, in spite of the autumnal blueness of the sky above, were largely barren and dry. These grand vistas were almost distracting, Yang Fudong wielding them like a painter, fully exploiting the colours of seasons, romantic and dramatic by turn. As the land rolled on, so too did

the soldier, with viewers left to ruminate on an end that clearly held no cinematic import for the artist's vision.

Close to the Sea followed a similar format, made up of a big, bold arrangement of screens and players, placed as members of an orchestra for reasons of both sound and visual effect. It was a concept that, in small part, accounted for the presence of musical instruments in the unlikely setting of a coastline beset by the elements. In the manner of their juxtaposition, each screen contained one member of this orchestra, standing on a solitary rock and surrounded by the sea, with each musician assigned a different instrument that played its part, as both solo passage and chorus. Implicit in this arrangement was the idea expressed in the Chinese proverb "playing flute for an ox"—considered an act of pure futility—the musicians played to the heedless elements alone, much like the Sirens trying to call Odysseus across the waves, luring victims to their death on the rocks.

In terms of narrative, Yang Fudong parachuted the audience onto his "island" and into the presence of the "survivors"—a pair of young lovers—with no explanation of what this place was, how anyone got there, or why they found themselves in such a situation. Nor, indeed, was there any clue as to whether they would ever make it back to civilisation. Two of the filmed segments were shot in black and white, their presence in the sea of colour disrupting the conventional logic of screen time like a flashback

device, adding a temporal depth to the work in the layering of "then" over "now".

In abstract terms, *Close to the Sea* functioned as a kind of existential version of *Lost*, the popular American TV series, but as if guest directed by Lars von Trier, or, alternatively, a modern-day Greek tragedy. Accentuating the sense of predicament, Yang Fudong had his figures sit astride a magnificent steed on the beach, gazing at the sea, as if poised to do battle with the elements, the shots angled upwards to invoke heroism in the face of adversity. That moment came with the couple suddenly in the sea, although it was unclear whether they were involved in an attempt to gain safety on the land or escape the island shore. Alternately calm and demonstrative, the sea lapped the shore as the couple struggled to right themselves in the surf. Viewers were left to contemplate their survival, for here too, Yang Fudong ensured that the fate of his protagonists remained convincingly unsure.

The Revival of the Snake, installation view

Jiang Xiaochun

7

Also known as Yan Dong, Beijing-based Jiang Xiaochun (b. 1981; Shandong) graduated from Yantai Art School, Shandong, 2001.

Few among those who follow China's contemporary art scene are, as of yet, familiar with the name Jiang Xiaochun, or, indeed, Yan Dong, the pseudonym under which this artist works. In character, his personality is insular, retiring. That nature is reflected in the style of his work—art that is the extreme of miniature. The majority of his pieces are so tiny that they barely seem to qualify as conventional artworks at all. The tiny and restricted surface areas upon which the compositions sit are as likely to be pieces of card—torn from a box or packaging—as a "proper" piece of paper, but size is by no means an absolute index in terms of the impact his art achieves.

Jiang Xiaochun's drawings work because viewers have to get unusually close in order to see them, and, by so doing, experience an instance of intimacy that turns curiosity into an emotional response to what is seen. Since graduating from art school over a decade ago, Jiang Xiaochun has worked diligently at his art—almost entirely behind closed doors. His first public showing, titled The Arrival of the Ship, came in 2010 and took place in a suitably small-scale gallery in 798, which was the perfect setting in which to see his diminutive drawings; to stumble upon them there provided the kind of discovery and experience that make engaging with art so rewarding.

He is also prolific. The vast majority of Jiang Xiaochun's works take the form of drawings, although on occasion he uses watercolour and Chinese ink to produce slightly larger, though still miniature, paintings. The latter are, on the whole, more consciously composed than the pencil drawings. But if describing the paintings as conscious compositions suggests that the drawings are somehow random, well, that is not the case. Rather, they exhibit a natural, intuitive unfolding to the structure of their fruition; it's as if, in the course of relaying a story through a particular scene, or collection of props and characters, each was introduced when their moment in the narrative arrived and had to find a place on the paper.

◀ *Judgement* (detail), pencil on paper, 154 × 111 cm, 2011

A *Young Maria, Frightened* (detail), pencil on paper, 29 × 39 cm, 2012

Jiang Xiaochun's vision extends to myriad figures, animal as well as human, and all manner of fictitious creatures. There is a great deal of fantasy guiding the way in which the individual elements are placed in relation to one another in the pictures. Jiang Xiaochun presents an integral world, and for all that it appears humorous or amusing, it is thoughtful too, for although preferring to remain far from the limelight, he is clearly not unaware of what is going on in the world. He simply internalizes it and transposes its essence to his small stage.

Seven, Jiang Xiaochun's third solo exhibition, signalled an incremental shift in direction. Most obviously, as seen here, his latest work had been subject to a shift in scale. A necessary one perhaps, for an artist used to producing artworks no bigger than postage stamps naturally presents an interesting challenge to a gallerist. How should such works be presented, much less priced? Surprisingly, given the simple nature of their execution, these small drawings require an inordinate amount of time to complete, too; but then, the single large work included in this exhibition, *Elephant*, took the artist an entire year to finish. Time is clearly essential to the intensity that is achieved.

A further aspect of the shift was the choice of subject matter and a calm, contemplative aura that hung over the works. There was no humour intended in this group, nor any sign of childlike silliness that lent his earlier figurative scenes part of their appeal. The dozen or so drawings exhibited here commonly held spiritual concerns, evidenced in Jiang Xiaochun's use of religious iconography, but also partially by the numerical title that he gave the show. References to heaven, seals, sacraments and

🔺 *Elephant*, pencil on paper, 154 × 190 cm, 2012

sins are immediate associations with seven in Western culture, while the number has equal resonance in Egyptian, Islamic and Chinese cultural frameworks. The motifs invoked in the drawings wove together simple elements that are universal in their expression of faith, innocence and mysticism.

One of the larger works, *Young Maria, Frightened* featured the angelic face of a child—a single angel wing extending behind her—accompanied by tiny scrolls, a mountain in the distance and circling planets and stars. Several drawings incorporated a sheep or lamb, or sometimes a stag, with neat, miniature fragments of text, there to approximate language, but not intended to provide meaning. The ultimate motif of faith was the Celtic cross, depicted with extraordinary detail in the filigree patterns of its ironwork. Similarly, there was the intricate rendering of the pages of an open book, intended to be as mysterious as the fifteenth-century (possibly hoax) Voynich manuscript, written in a cipher that continues to puzzle historians to this day. A particularly detailed picture was presented in a layered composition familiar as a Hindu or Buddhist worldview; calm and meditative, 7 looked to a higher plane.

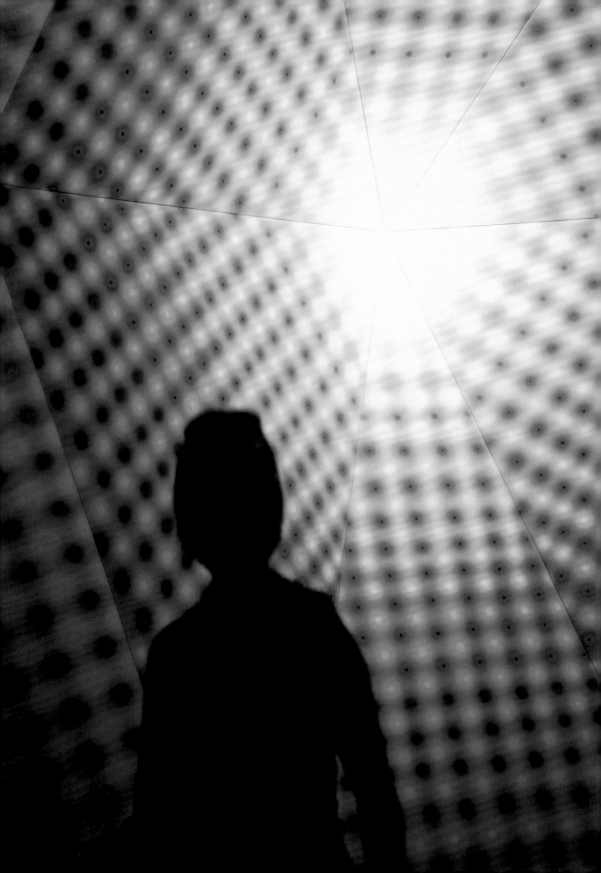

李姝睿

Li Shurui

The Shelter / A Wall

Beijing-based Li Shurui (b. 1980; Sichuan) graduated from the Sichuan Fine Arts Institute in 2004.

Li Shurui is—as yet—little known in China, or beyond. But in terms of what she creates, as seen in the various works that have appeared in several exhibitions in the last two years, this artist appears to have great potential. She is a painter, in a very contemporary sense, meaning that she does not limit herself to conventional means. She has experimented with sculptural forms, giving her paintings a physical or structural volume, which results in a free-standing form. She has worked on scales both large and small, using widely different materials.

Thus far, it would seem that her goal is to break free from a straightforward, flat picture plane and produce a work that is experienced through more than just vision alone; although to judge by the visual schema she deploys in general, the impact that can be achieved on the eyes is paramount. In terms of content or image, Li Shurui's works are abstract; there is no immediate sense of concrete form in these paintings. The compositions are highly patterned in a manner once associated with Op or Kinetic Art of the mid-twentieth century. This is not perhaps the artist's point of departure. In this age of technological image making, Li Shurui has a more focused interest in the visual phenomena generated by electricity, by infrared imaging, and the manipulation of the visual experience that can be achieved using computer software applications and filters.

The inspiration and subject that set Li Shurui on this course was light. In the short span of her career, she has produced an impressive volume of canvases, small and large (and very large), most of which are pictorial approximations of electric and neon illumination. She began with the pretty kind: neon as if seen on a dark night and in the aftermath of rain, such that colour is infused with myriad reflected depths. The early paintings were particularly psychedelic, and possessed of a hypnotic allure—part of that prettiness remains in the more recent works.

◄ *The Shelter: All Fears Come from the Unknown Shimmering at the Edge of the World*, acrylic on canvas, multiple-panel painting installation, 1560 x 800 x 550 cm, 2012

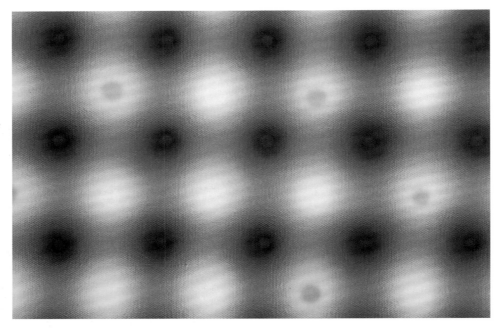

▲ *Light of the Sky No.7* (detail), acrylic on canvas, 90 x 90 cm, 2012

In one presentation this year she showed a group of small miniature watercolour paintings done by hand (as opposed to being airbrushed). The combination of thick paper and watercolour pigment produced a textural quality that the canvas paintings lack— the larger paintings are airbrushed, which denies any handmade mark of any kind, and gives the surface finish a flat, blurred quality that borders on mechanical reproduction. Demonstrating that she is not stuck on one approach, she also showed a pair of small acrylic works of an intimate scale that were delicately controlled and again achieved a different emotional timbre.

The two large works Li Shurui produced this year confirmed her potential in other directions: namely those of scale and complexity. *The Shelter: All Fears Come from the Unknown Shimmering at the Edge of the World* was a full-sized structural-installation painting; a curved structure over fifteen metres in length that resembled the façade of a gothic mansion, the spires of the arcs reached to a height of five metres.

The Shelter: All Fears Come from the Unknown Shimmering at the Edge of the World both loomed over and encroached upon the viewer's physical experience. The sense of menace—as raised within the title—was not helped by the extreme approach to lighting used to create an atmosphere. Blinding stage lights shone full in the face of both canvas and viewer, resulting in a drama that was more vaudeville, of the high Victorian style, than David Lynch, say. The dark (almost black) pigment used to create the surface painting was closer to Op Art than ever. Yet what was achieved here was memorable.

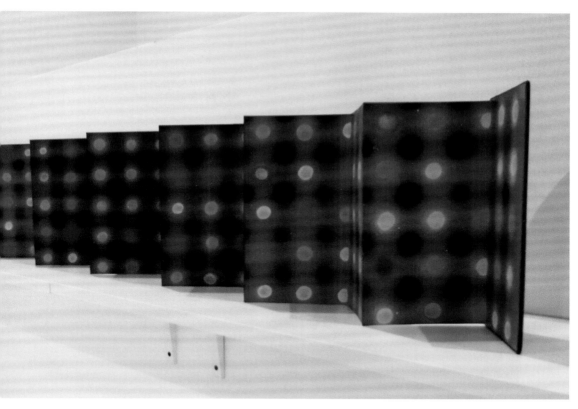

▲ free-standing watercolour painting on paper, 20 x 300 cm, 2012

The second structure was *A Wall*. As the title suggests, this piece brought Li Shurui back to the flat plane that she handles so well, here made fractal by a jigsaw-puzzle combination of multiple parts pieced together to complete the wall-sized painting. Gone were the gothic spires and the distracting lights. Instead, you could walk into the gallery and almost not notice that the end wall was an artwork. The colour—dove grey and celadon green—although perfect for the work, was so soft in tonality, and for achieving the blurry soft edges of the dots, that *A Wall* was almost invisible from afar; just that, a blue-grey wall. As you drew near, though, the optical illusion became apparent. It was possible to see shapes emerging from the shimmering, powdery tones.

This may suggest that *A Wall* verged on being decorative. There is an element of truth in that; standing in front of it, you could imagine it in a designer architectural space. Yet the essence that lends Li Shurui's work its intriguing energy managed to suggest more than surface. A determined character, she has no fear of trying new things to see where they may take her. The discovery that not all ideas work out equally well helped shape the concept for *The Shelter: All Fears Come from the Unknown Shimmering at the Edge of the World*, and out of that came *A Wall*. I'd say that for her work with light and colour, and for sheer craziness, Li Shurui remains full of potential—an artist from whom to expect great things.

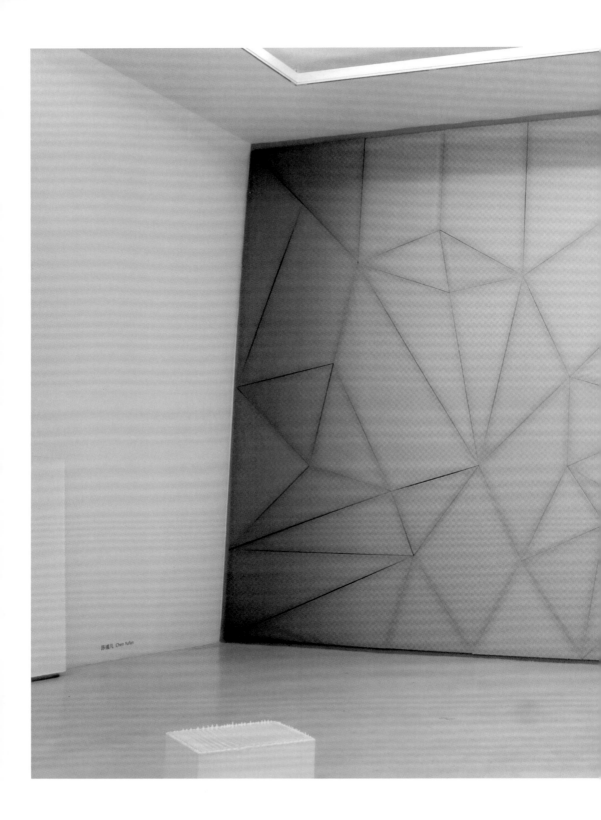

陈暄凡 Chen Man

▲ *A Wall*, multiple-panel painting installation, 600 x 900 cm, installation view, 2012

张鼎 Zhang Ding

Buddha Jumps over the Wall

Shanghai-based Zhang Ding (b. 1980; Gansu) graduated from the Northwest Minority University in 2003, and studied in the new media department of the China Academy, 2003-04.

The intriguingly named "Buddha jumps over the wall" (佛跳墙 ; *fo tiao qiang*) is a popular dish from Fujian. A complex medley of an excessive list of ingredients, the dish is said to have been born, like so many great culinary combinations, of necessity in an age when food was neither so readily available nor easily preserved. Not knowing where his next meal was to come from, the originator accidentally arrived at the mix using leftovers and offerings that came his way. For this reason the dish requires a period of days to complete, and includes shark's fin, sea cucumber, abalone and Shaoxing wine (to name but a few choice ingredients). The name of the dish reflects the powerful appeal of its aroma, said to be so enticing that even a vegetarian monk, the buddha of the title, could not restrain himself from sneaking out of the monastery (literally "jumping over the wall") to steal a taste.

As an artwork, *Buddha Jumps over the Wall* played with the moral and ethical conundrum of disobeying rules, vows, or, simply, of breaking free of imposed regulations. The work was a compendium of multiple elements, a veritable circus of acts, involving a general overarching installation with sculptures, a video, paintings and a performance as interwoven components. There were as many elements, one might say, as it takes to make the dish, and an ensemble as complex, over the top and hard to digest as that meal, too. But Zhang Ding's *Buddha Jumps over the Wall* was at least as memorable as we suppose that original buddha's experience was.

That was certainly the case for those present at the exercise in indulgence that was the fully prepared dish's arrival "hot from the stove" on the show's opening night—literally speaking, that is. Any time after that, experiencing the exhibition was rather like arriving late for dinner, finding the plates still on the table and a tantalizing whiff of the original aroma in the air, but the power of the actual dish (such that made the buddha jump over the wall) was left to the imagination alone to reconstruct. You could watch the video and see the sculptures; you could peruse the paintings and even sit in part of the

◄ *Buddha Jumps over the Wall*, installation view, 2012

Buddha Jumps over the Wall, colour single-channel video, 2', 2012

installation; the essence that would corrupt a monk, however, was dissipated.

Having said that, the violence of the video on display here was intense—the shock of its explosive action arresting. Yes, the viewer immediately realized, the animal figures it featured were stand-ins made from plaster, and that the bullets and blood were over-the-top special effects more usually seen in Asian gangster movies. Nonetheless, the effect was powerful enough to prompt reaction—running away more than jumping over a wall; deadening the appetite not whetting it. This was aided by the shadow of the first sculpture encountered, which fell over viewers as they stood to watch the video. The *Men in Black*-meets-Neo figure of a man, pointing a gun straight out in front of him, was placed directly opposite the screen, such that it seemed as if the shots exploding on film had been unleashed from his barrel.

Inside the main exhibition area was first a scene of carnage. A second sculpture towered to the left, similarly slick in attire, but where holding a cleaver, was presumably there to represent the chef. The mess—the carnage visible upon entry—was due not to cooking, but to a riotous process of consumption, as if a gaggle of starving beings had descended upon the food in a frenzy of attraction, unable, in their desperation to consume, to control their manners. Such is the power of a dish that could distract a buddha, after all.

In the centre of this space was a circular pavilion, shaped something like a fairground ride, but the seats here were intended for an orchestra, which played at the exhibition opening while Zhang Ding's great dish was served (commensurate with the excesses of the original Buddha Jumps over the Wall that inspired it). Behind the pavilion was a long galley, running the length of the space along one wall, rather like the picture galleries in the great halls of aristocratic houses, where dances would be held. Here, too,

▲ *Buddha Jumps over the Wall*, installation view

➤ dancers at the opening night performance

on the night of the opening, ballroom dancers took to the floor as the orchestra played. This was, to all intents and purposes, exactly like Zhang Ding's previous solo exhibition, Opening, produced in 2011. True to its title, Opening was simply that: an opening party, complete with DJ and dancers set on pedestals throughout the gallery space, as clubbers would expect to see in their favourite entertainment hotspot.

Zhang Ding has long been masterful in his management of forms in exhibition spaces; his ability to command the aura with an experience of art is widely respected. With *Buddha Jumps over the Wall*—despite the fact it was a shame latecomers to the scene were not privy to the full fare—his sense of the big picture, of which all the components were essential parts, was no less so. But the best thing about the work was how perfectly it reflected the times: namely the feelings of desire and ambition, and the indulgence they demand if they are to be completely fulfilled. *Buddha Jumps over the Wall* was about the visible trappings of life today, which we so often perceive as being "just over that wall" (the grass being ever greener over there), and which, being in possession of means or not, few are able to resist.

What is left when indulgence has been afforded? Only destruction is visible. How dreadfully hollow, alien and brutal it all seems in the cold light of day, when appetites are sated but the hunger in the soul has not been relieved one bit. History does not record what became of the buddha, if he lived to regret the breaking of his vows, yet the issue remains of what control means to the way life is lived today—of what is enough, and what is adequate for our needs; what we should resist and that which we should heed. In terms of his art, Zhang Ding revels in exactly this type of confusion.

Hu Xiangqian

胡向前

Protagonist

Based between Beijing and Guangzhou, Hu Xiangqian (b. 1983; Guangzhou) graduated from the Guangzhou Academy of Fine Arts in 2007.

Hu Xiangqian is a performance artist. Performance art is, by intention, confrontational in nature; you should know you've had an encounter with a performance artist. That does not necessarily mean in an especially aggressive sense, although it can be, but certainly as a form of intervention in the spectator's daily sphere. Hu Xiangqian clearly loves to work live before an audience. He is also a great performer, period, who thrives on eliciting an immediate response. But in the context of a conventional exhibition, which runs for an extended period of time, and without control over audience visiting times, this is not always possible.

Where live art is not feasible, the performance artist may choose to present recordings of their live activities in the form of a video work, or simply stage a performance to the same end. The distinctions here are subtle and nuanced, but have a particular effect upon the viewer's experience of the final piece that confronts them as an artwork. It is Hu Xiangqian's staged works that provide evidence of his acting skills and reveal his versatility as a performer. His solo exhibition Protagonist comprised three video works—*Look Look Look!*, *Acting Out Artist* and *The Labor Song*—each rather different in form and content, but that were illustrative of the wide-ranging skills and qualities that his approach to art draws upon.

In terms of subject matter and focus, these three pieces provided intimate reflections on the spirit of the era—its music, culture and values, and its unresolved relationship to the past. It is important to note that Hu Xiangqian is from Guangzhou, which imbues the oeuvres of artists working there with a distinctive cultural sensibility (evident in the styles of artists such as Chen Shaoxiong, Xu Tan, Cao Fei and Zheng Guogu). This is partly due to the region's proximity to Hong Kong, but equally because of its singular concentration of industry and commerce, and its unique dialect.

That language was a fundamental aspect of the style and experience of *Look Look Look*, a live performance delivered in Hong Kong in May 2012, where it was

◄ *Acting Out Artist*, colour single-chanel video, 14' 15", 2012

A Labour Song I Night, colour single-chanel video, 7' 12", 2012

recorded. It was presented here unedited, but with the addition of subtitles, and showed Hu Xiangqian in a character role he first flirted with in 2008, in a piece entitled *Sun*, the recording of a performance related to the artist's embrace of the distinctive cultural "look" of his African friends in Guangzhou. That performance entailed first braiding his hair before viewers watched him spending hours in the full glare of the sun with the goal of tanning himself "black".

For *Look Look Look!* he dressed as a Bronx rapper might, performing live for Long March Space's tenth anniversary celebration, which was held on a boat (a junk) in the Hong Kong harbour. His audience comprised invited guests, artists, art world figures and VIPs, who sat around the edge of the narrow area that served as Hu Xiangqian's performance space, as the artist bopped and ranted from one end of the arena to the other. Onlookers were bemused. The fact that Hu Xiangqian rapped in Cantonese obfuscated the more inane aspects of the lyrics, which he penned himself and seemingly centred on phrases such as "piles of poop", "fuck your mother", "onetwothreefour" and, well, more piles of poop.

There was something hilarious about the entire setup as much as the content. Watching the recording in the gallery, viewers had the benefit of subtitles for the lyrics, but for some that knowledge may well have diminished the proficiency of the performance: from the deliberately inane to the merely ridiculous. But while the performance was, on the one hand, refreshingly light as art, Hu Xiangqian managed to keep it edgy by means of a tight-faced energy and a degree of aggression that was entirely appropriate to the role.

In terms of mood and agenda, *Acting Out Artist* was the diametrical opposite of *Look Look Look!*. The title of this second piece was self-explanatory, accounting for the entire plot of the staged performance. Here, Hu Xiangqian naturally took the lead role. The transformation from rapper to artist-intellectual was utterly convincing. The sequence began at the start of the artist's day. He is seen in bed, swathed in silken

△ *Look Look Look!*, colour single-chanel video, 4' 40", 2012

sheets, languidly poetic in the manner of a latter-day Shelley (*Acting Out Artist* pivots on the twentieth-century modern cliché of the existential artist figure, by which it is hard to reference a Chinese equivalent), perusing a text as a thoughtful poet might. Having risen, the artist's dress and manner adapt a French existential stereotype to the present era, appearing more than adequately intellectual and articulate.

In the slow pace of the action, the viewer is encouraged to note the artist's poise, his slick mantle of manicured hair, the well-mannered placing of his hands on his lap, and the elegant tailoring of his stylish suit. All is earnest concentration as he engages with visiting curators from "the West"—a seeming counterpoint to Shanghai artist Zhou Tiehai's 1996 parody of the art world in a film titled *Will*. Since Hu Xiangqian's film is silent, and without subtitles, we never quite know who the visitors are. The silence is ambiguous. Does the artist mock the pretensions of the visitors to understand his work? Or is this merely a demonstration of how deals are done in the art world today?

Hu Xiangqian's penchant for satire was rounded out in the third work, *The Labor Song*, which was also composed by the artist. Parodying the nation's proliferation of televised singing shows—many of which are peopled by members of the military belting out patriotic tunes—Hu Xiangqian takes one part of a quartet indulging in a private karaoke moment concealed in the garret that is their watchtower or guardhouse. Or so we are forced to assume since the space is so small that the camera placed in the centre of the group has to swivel constantly to keep each member equally present.

Garbed in regimental uniform more Beefeater than People's Liberation Army— it is in fact the uniform of the Irish Guards, as worn by Prince William on his wedding day—white-gloved fingers snap to the beat as they harmonise; the token female among the three men beams with a bright-eyed, beatific smile suggestive of the warm unity experienced by being part of this intimate grouping. A more cynical mind would read all manner of indoctrination into the work, indicated by the uniforms, as well as a resistance to conformity by singing in the dark. These three works confirm Hu Xiangqian as a singular force amongst China's young performance-based artists.

王思顺

Wang Sishun

Liminal Space

Beijing-based Wang Sishun (b. 1979; Wuhan, Hubei) graduated from the Central Academy of Fine Arts in 2008.

The choice of "liminal" as the titular adjective for this exhibition said more about the position of Wang Sishun's art than he might have imagined. The definition of a "liminal space" as representing a threshold of the senses—liminal meaning the point beyond which a sensation becomes too faint to be experienced—was certainly applicable to the works included in this show. But it also spoke to the nature of Wang Sishun's art, which, surveying the works he has produced thus far in his brief career has proved subtle to the nth degree. His pieces are quiet, slight even, and not always visually stimulating. They are perhaps more Zen than minimalist, and centre on similarly cerebral conundrums. In this context, with Liminal Space, Wang Sishun did not disappoint. Well, not unless the viewer was hoping for the kind of visual extravaganza provided by the likes of Madeln or Zhao Yao.

Entering the gallery, most viewers probably stopped in their tracks, gazing around the expanse as they tried to identify exactly what it was they were supposed to be looking at. The exhibition space contained several sturdy white pillars. Partly concealed behind one was a large charcoal-steel-grey form, which vaguely echoed the shape of the white pillar adjacent to it (although it was less than half the pillar's height). The silent steel box did not immediately say "art". Over to the left was a streak of cobalt blue. All else was grey. At this point, a less patient visitor might have turned tail and moved on, especially as there was plenty of energy evident in the adjoining space where performance artist Hu Xiangqian's Protagonist was in full flow. The space in which Wang Sishun's exhibition was sited suddenly felt very luminal indeed.

If curiosity pulled visitors in just a few steps forward their sense of the exhibition would have been altered. More sensibly aware of the geometric grey solid now, and having registered the thin blue line angled against the wall, their visual senses were thus suitably prepared to see a third work. On the floor, to the right of the path into the space, lay a plastic bottle cap with a synthetic yellow tone that perfectly complemented

◄ *Desire and One of N Points*, chalk, plastic, 6 x 5 x 1.2 cm, 2012

A *2:30 am*, object formed from granite, 210 x 90 x 34.5 cm, 2012

the cobalt blue line on the far side of the room. It was but a tiny spot of bright colour, set against the expanse of the gallery's grey floor, and therefore easy to miss.

We might notice such things on the street, but rarely give them a second thought, other than to blame a careless passerby for missing the trash can again. This yellow bottle cap was obviously special since it had a white circle chalked around its perimeter as if to mark a no-go area, a boundary over which a casual bystander should not pass—impossible here given the diminutive scale. White chalk lines are habitually associated with police cordons and accidents. In a gallery space, if the intention was to keep viewers away, you'd expect a railing or "do not touch" sign, not a thin chalk outline all the way down there on the floor. But now it was clear that, in his choice of objects as mediums of expression, this artist had something very specific in mind.

In fact, the works of which the exhibition was comprised all came with a point that was not immediately obvious in the actual installation. The bottle cap was titled *Desire and One of N Points*. When creating this piece, Wang Sishun first threw the bottle cap on the gallery floor in a random fashion. He then drew a circle around it and re-threw the bottle cap over and over again until it landed perfectly within the chalk circle. Ah, so not as easy as it might have at first seemed. That was the artist's only performance-related work, although he provided a second for the audience to conduct: a single white rose pinned to a wall, its bloom hanging downward, so that the correct way to enjoy it

▲ *Angle of Sadness*, stainless steel, lacquer, 300 x 3 x 4 cm, 2012

was, in Wang Sishun's words, to 'bend down, and look back between your legs'.

The subject of legs spread apart was also related to that mysterious, looming, steel-looking tower—of granite it turned out—that stood near the pillar, its darkness silently static and menacing in the otherwise empty space. Closer examination revealed it to be an upended triangular form, more specifically, for the artist, 'an isosceles triangle with an angle of 105 degrees, which is the angle between the hour hand and the minute hand of a clock at exactly 2.30am', he explained; a random association that played with rational logic. But, as the artist pointed out, it was a 'nice angle', one that 'does not incite the anxiety and nervousness of a sharp acute angle, nor is it as inevitably solemn as a right angle. It looks like the nerves have been relaxed—sluggish legs are spread apart.'

So, finally, what was the point of the blue pole leaning against the wall? It transpires that it was the perfect imitation of a similarly steel pole that Wang Sishun had noticed incidentally 'leaning against a shed in the Heiqiao area'. The artist called this work *Angle of Sadness*, because, to his way of thinking, 'there is sadness to the blue colour of the rod and the angle at which it is placed.' Wang Sishun's works might appear minimal, gestural, or antithetical to what is thought of as art, but understanding the inspiration and impetus behind the handful of works in this exhibition ultimately reflected back upon the titular reference to "liminal"—an artist standing on the threshold of something rather promising.

海波 | Hai Bo
Solo

Beijing-based Hai Bo (b. 1962; Changchun, Jilin) graduated from the Central Academy of Fine Arts in 1989.

Hai Bo works in the area of photography. More specifically, he produces photographic images that are specifically focused on the element of time. His work is steeped in nostalgia—memories of the past predicated on China's northeastern Dongbei region, where he grew up and which evinces a particular aura of human existence for the artist, one that is embodied in both the human and agricultural landscape. Where the area he seeks to describe is mostly rural so are the folk that enter his frames. In the series of images shown here, these figures were clearly aged, having reached the twilight of their years. This lifelong achievement, if it can be described as such, for Hai Bo's attitude on the subject is somewhat ambiguous, was made metaphoric by the fading daylight conditions under which these venerable elders were photographed.

As was demonstrated in Hai Bo's first successful series of photographic works—a series of photographic diptychs he titled They, begun in 1997, which recreated photographs from the 1960s and 1970s. This involved tracking down the individuals who appeared in the early photographs and persuading them to sit again. The final diptych saw the original image placed side-by-side with the recreation, comparing the "them" of yesteryear with the survivors of today, and leaving gaps to commemorate those who had passed on—this artist is prepared to wait years in order to get the grouping, lighting, environment and aura absolutely right; for the perfect moment to come. This may be understood as an extraordinary take on Cartier-Bresson's decisive moment perhaps (if not a rather extreme example of absolutism as a strategy). For Hai Bo, it is the personal past that counts, rather than a formulated conceptual trope about attitudes towards the past. In a subtle way, this was the substance of *Four Seasons* (2003), which captured the exact same point of the equinox, which marks each seasonal shift, on a spot where Hai Bo played as a child (this required perfect weather conditions and nature was not always accommodating, thus the series took several years to complete).

◄ *Photographic Diary - A Man in the Shade* (detail), black and white photograph, 60 x 100 cm, 2008

▲ *Early Evening Light*, right panel of triptych, black and white photograph, 150 x 200 cm (x 3), 2009

In the new works, the personal dovetailed with a collective consciousness. The nature of the content is familiar to many in China, and in particular to today's oft-overlooked masses that constitute the expanding bracket of the country's aged constituents. It is these elders of splintering, disintegrating communities who make up a large portion of the mostly impoverished population that remains tied to the region of Hai Bo's hometown. In recent decades, young people have begun to leave the countryside in droves; an ironic turnaround from a half-century back, when Hai Bo's parents belonged to the nation's idealistic youth, spurred on by Mao to settle these northern territories and transform them into the agricultural heartland of the nation (not its rice fields, but its wheat and grains).

Gladly did they go, too. And there, now captured for eternity, was a lingering group of individuals, contemporaries of his parents, sitting silently in one of Hai Bo's latest photographs. It is not possible to identify clearly any one of the old men gathered on the benches, for as they face us, the audience, against the light their faces are lost to the shadows. But neither do we need to know who they are for these photographs are not intended as portraits. Instead, we are to recognise types, representatives of humanity in an increasingly inhuman and emotionally cold world. As in even the darkest tragedy, hope is to be found in nuanced views of the ordinary. Here, Hai Bo included a number of still-life compositions interspersed with silent scenes of empty, seemingly lifeless spaces.

Hai Bo likes his photographs dark, which can be a failing in the work of Chinese

Photographic Diary - Baoyi and His Friends, black and white photograph, 60 x 100 cm, 2008

photographers: the images are often made to feel heavy-handed and myriad details are lost. Those presented here left a haunting impression of what photography does best, which is to capture incidental truth that, even a short time after, has the power to surprise. Hai Bo surprised, too, with the astonishing scale of two monumental photographs: a six-metre wide panoramic landscape at the start, and a towering billboard-sized image of a wall at the end. Scale can make photography an awkward medium—glass is frequently obstructive to the viewing experience, although on this occasion it was not an issue. The success of the mounting added to the impressive quality of the larger works. Distinct from the other works in the show, these were colour pieces, not black and white, yet the dour tonality of that colour managed to achieve a similarly desolate aura

In the large panorama, a solitary figure seated on a tractor occupied the central position, acting as a pivot to the entire expanse of land, the block in the centre of a seesaw. At the bottom of the towering wall, viewers found themselves facing a group of blind fortune-tellers waiting for customers to pass by. That blindness—which is to say the subjects' lack of awareness of the photographer, much less of future viewers in unknowable art spaces—injected a voyeuristic air of intrusion into the image. It was discomforting to realise how long it took, staring at the figures, to understand that they were blind. The scale brought to this subject was familiar to the era of Communist ideology. Inviting a parallel to Luo Zhongli's cathartic painting *Father* (1980), it seemed plausible that Hai Bo was contemplating the failure of the system to provide for all its subjects. Overall, this collection of photographs seemed to explore 'the accumulation, the multiplication, of loss', a phrase used to describe Julian Barnes's novel, *The Sense of an Ending*, about the past. Here, Barnes attempts to pinpoint the tipping-point moment when mortality is acknowledged and nostalgia then floods the senses; where Hai Bo's pictures speak, it is this topic upon which they are most articulate. With a similar lightness of hand, these photographs document not just individual lives fading fast, but that of an era, of a way of life.

The Blind (detail), colour photograph, 350 x 900 cm, 2012

周滔 Zhou Tao

Collector

Guangzhou-based Zhou Tao (b. 1976; Changsha, Hunan) graduated from the Guangzhou Academy of Fine Arts in 2006.

First seen in Guangzhou's Times Museum, where Zhou Tao presented the work as part of an "open studio" project, *Collector* is a film as poem on the subject of the artist's adopted home in the Guangdong area. 'You observe one even bigger world and universe through film,' he has said, and *Collector* reveals how. Produced between April and June 2012, Zhou Tao shows this world through the prism of his own very different experiences—including a year spent living in New York (from 2009 to 2010). In terms of the subtle details observed, *Collector* seemed to be seeing this world afresh, almost as if he were an outsider looking in.

The film begins with a solitary elephant, in a zoo we presume, standing before a pool of water. The elephant swings its trunk and sways its body, lifting a single foot, as if preparing to enter the water. In building up to the action, here, the elephant's motion is presented as a dance. But it is also the behaviour of a caged creature—an anxious and obsessively repeated action that is believed to indicate the onset of psychosis in captive animals. Zhou Tao raises this thought and then has us leave the elephant as the camera moves on. We are now aware that we are in a place of heat, of claustrophobia, and ambient discomfort.

As this registers, viewers are plunged into the heavy rain of the region: a road, at night (or what might just be an overcast day), studded by flickering lights, as the rain falls on a car caught in the deluge, almost concealed beneath a canopy of trees. There is now mystery here—signs of nature's force. After the rain, we are in fields among peasant farmers, steeped in local vernacular as idyllic as one of Duan Jianyu's paintings. The fields are an expanse of land, low and wide, rolling out to the horizon. The peasants squat in rich, liquid mud. They weed; they toil. All is peace. And the soundtrack is just that: peace—quiet, incidental, ambient sound that accompanies the travels of the cameraman, the artist.

◄ still from *Collector,* colour single-channel video, 22' 27", 2012

A still from *Collector,* colour single-channel video, 22' 27", 2012

He leads us from fields to forest, to spaces where people leave behind the daily grind, and go to exercise and take fresh air. There are spiritualists practicing, lovers entangled, and simple individuals—from the great mass of humanity—anonymously going about their day in the quiet of these lush, dense surroundings. Upon leaving the forest, having been privy to a series of suggestive sexual encounters in the half-light within, albeit only partially seen, the day's end seems to be approaching. We are outside a home. Rain is falling again. A wind stirs the heavy branches of a tree outside the window as only an approaching typhoon can; inside a family plays, the children oblivious to the weather, or the gathering darkness. Inside it is safe. It is home. We are outside, with the artist, reminded that we are spectators who do not belong, as he is himself.

Collector ends back in the zoo where balance is restored to the life of the elephant as a mate ambles to the rescue. There is hope, there is love, and perhaps nothing is quite what it seems here, although the emotions that have been experienced in the process of watching the film are palpable. Although young, Zhou Tao has experience working with video and performance that enable him to invoke or to suggest narrative as and when it suits his purposes. *Collector* was in many ways ambiguous. Earlier works were more performance based, such as *Mutual Reliance* (2009), which contained a subtle, well-deployed humour.

In this particular piece, two young men, of approximately the same height and build, support each other physically, taking it in turns to rely upon the other to move from right to left, across an urban stage in an industrial part of Guangzhou, across the forecourt of a building. They completely ignore everyone else around them, those going about their daily business, and, as they lean, and are dragged to the next position, are totally absurd

in their actions. A similar piece was performed in New York, *East 6th Street to Location One* (2009-10), in which Zhou Tao also walks from one site to the other, invoking the same reliance upon a partner's body as they make the journey from A to B.

Zhou Tao has a feeling for nuance and narrative in image—the moving image in particular. His stories are not plots. They are essential seams of human experience and psychological states. For example, in both Guangzhou (2007) and New York (2009), he managed to spend a whole day "living" in a supermarket or department store, as he would at home, without attracting untoward attention (an easy task in China, perhaps, where whole families hang out at Ikea, but harder in the US). Also working with endurance as a theme, *Tide* (2008) followed one cycle of the title subject's ebb and flow. Its opening sequence echoes the spectacular recrafting of the horror of the tragic drowning of twenty-three cockle pickers at Morecambe Bay (in northwest England in 2004) captured in Isaac Julien's *Ten Thousand Waves.*

In *Tide*, a figure sits in a stone shelter on a beach. The tide is clearly approaching. Zhou Tao sits inside this castle of rock, which he built himself upon the sand, complete with corrugated iron roof. The work is beautifully paced, building to a terrifying moment of underwater panic as the castle appears to be entirely engulfed by the incoming tide—the artist silently and tenaciously clinging for all he is worth to the interior of the rock home. So where much of Zhou Tao's work is performance based, *Collector* was an interesting development: an exercise in discovering that what happens in daily life, and in full public view, is often far stranger than even the false nature of invention. Its revisiting of a familiar place was a timely invitation to reconnect with aspects of daily life too easily taken for granted.

◄ ⬆ *Tide*, colour single-channel video, 13'45", 2008

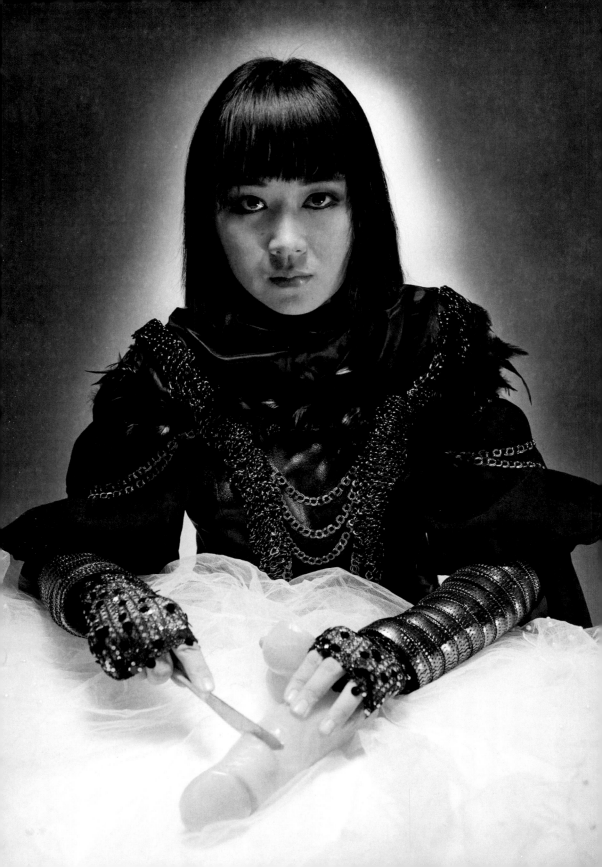

Pei Li

Generation P

Beijing-based Pei Li (b. 1985; Changzhou, Jiangsu) graduated from the New Media Department of Hangzhou's China Academy of Art in 2008, and the Beijing Film Academy in 2011.

Pei Li is a young artist. In the several years since she graduated in Hangzhou and moved to Beijing she has produced three significant works and participated in a handful of shows. This exhibition, Generation P, was her first significant solo presentation. It was notable for two new works, *Copycat* and *Healing Mushroom*, both of which took the form of video installations and featured the artist in a starring role. *Copycat* made a double play on the meaning of performance as art and the status of women as artists, while *Healing Mushroom* focused on the damaging effects of loneliness, isolation and alienation. Both are topics that Pei Li has explored before, suggesting that they are pertinent to this generation of largely single children in China.

 Copycat also took its cue from Marina Abramovic's reenactment of key performance works, her own as well as those of her peers, in a sequence she titled *Seven Easy Pieces* (staged at the Guggenheim in 2005). In the wake of Abramovic's more recent—and hugely successful—2010 solo exhibition The Artist Is Present, in New York's MoMA, performance art has found a sudden legitimacy with mainstream audiences. Not everyone likes it, but today it is far from being as strangely mad as many of its key, defiantly dangerous stunts implied. In China, the nature of performance art—or its role and ethos—remains an open debate. In the 1980s, performances here were more like "happenings", a form of live event that began in the public realm of Europe and America in the 1960s, the decade of "free expression". In the 1990s, performance in China earned a direct association with nudity and, thereby, with provocation.

 Performance was always going to be provocative, but its relationship to the body of the performer, and the clothed/unclothed state of that body, received little direct discussion—this is one aspect Pei Li addressed, in a subtle way, which aligned it with feminine modesty. The aspect of provocation across which the history of the genre in the West is strung has little resonance thus far in China. Or does it? This was also a question that Pei Li explored in creating *Copycat*, again using rather subtle means. How

◄ *Copycat: Restaging Kusama by Araki*, black and white photograph, 2012

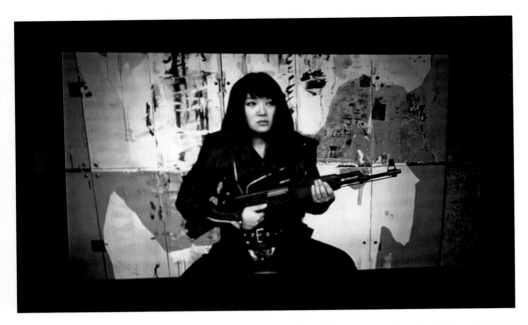

Copycat: Restaging Abramovic Restaging Action Pants: Genital Panic, colour video, installation view, 2012

well did she answer these questions? In copying Marina Abramovic, Pei Li's approach closely followed the mindset of her generation, being confident and independent, and yet not. When Marina Abramovic restaged those well-documented performance works in *Seven Easy Pieces*, each was performed, in turn, over the course of seven consecutive days—each one for a total of seven hours. Pei Li did not go in for that sort of endurance, although she did go to extreme lengths to achieve a cosmetic effect that dovetailed perfectly with the original persona of the performance artist, and their costume and props of choice. And so there was an accent on authenticity, but more in the vein of acting out the performances, rather than restaging them in the manner of Abramovic.

Pei Li grew up in a world of globalised culture and social networking that experiences most news or facts as sound bites: virtual visions of truth as entertainment and not its actuality. This distance from reality makes people fearless. So, dressed in leather crotchless pants, holding a machine gun, *Copycat* began with Pei Li acting out Abramovic restaging *Action Pants: Genital Panic*, which was originally devised and performed by Austrian artist Valie Export—inspired by the Actionist aura of Vienna created by a group of artists who challenged every order of social, political and artistic taboo—in 1969. Similarly, Pei Li acting out Abramovic restaging Joseph Beuys's 1965 performance *How To Explain Pictures to a Dead Hare.*

To these and others, Pei Li added several choices of her own, which were saliently illustrative of the times, and her own take on the world. In terms of art, a

recreation of a photograph of Japanese "spot" artist Yayoi Kusama (taken by her countryman Araki), which had her swathed in tight-fitting leather preparing to slice away at a substantially-sized rubber dildo with a deadly blade. In terms of humour, Pei Li enacted Tracey Emin in her tent in the process of notching up the sexual experiences that would adorn that famous work—and so we saw the tent jiggling to a rhythm of passion. In terms of emotion, Pei Li dipped into the character of one of Lucian Freud's models, a woman who was also his lover, as pictured in her heyday in 1967.

These (re)enactments were cleverly imitated with a lightness of touch that managed to be provokingly ambiguous. The works were easily read as being photographs, but were in fact all moving images. The artist was seen in character, holding herself as still as possible in each of the performance postures, usually for a few minutes or so. Everything was done in the spirit of the present era (so not entirely about exacting authenticity). Further, Pei Li is not comfortable with nudity, so, physically speaking, not everything seen was real. That was an interesting touch.

The twenty-minute video work *Healing Mushroom* was more consciously enigmatic. A narrative film sequence, shot in black and white, it told the story of a person experiencing a delusion—of believing themselves to be a mushroom—for which they are institutionalized. The first part of the film follows the delusional person—acted out by Pei Li—moving through an urban landscape, shielded beneath a clear plastic umbrella (nicely mushroom-shaped), silently standing in postures intended to suggest

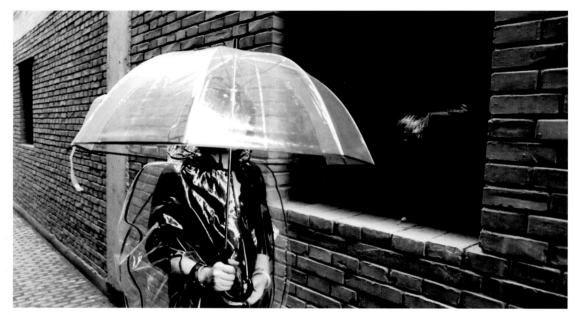

▲ *Healing Mushroom*, black and white single-channel video, 20' 03", 2012

▲ Copycat: *Rebuilding the Rights of Statues,* colour video, installation view, 2012

a mushroom springing up somewhere at random. The second part of the film tracks the process of recovery, courtesy of a doctor's act of understanding, which is to say placing themselves in the shoes of the sufferer and walking them back to normalcy.

Healing Mushroom danced along shifting parameters of what is normal/different, sane/disturbed, ignoring the causes of delusion or a moral debate about mental affliction. The project was predicated on highlighting the criteria that societies use to diagnose difference, which shift dangerously from era to era, and culture to culture, although the issue at the heart of the film was less about defining normal/abnormal and more about assuaging loneliness. Connecting with her audience is an ongoing aspect of Pei Li's work, thus the final element of *Healing Mushroom* was a continuing performance: anyone experiencing a bout of loneliness or isolation may call her up for a chat on the phone number she provided.

Li Dafang

Throw-back: Jin Zhan's Messy Growth, His Language and His Relatives

李大方

Beijing-based Li Dafang (b. 1971; Shenyang, Liaoning) graduated from the Lu Xun Academy of Fine Arts in 2000.

Li Dafang's approach to composition in his paintings turns the pictorial space into a theatre stage. That atmosphere was unusually marked in the new works presented in this exhibition, aided too by the provision of a very literary title: Throw-back—Jin Zhan's Messy Growth, His Language and His Relatives. Whilst ascribing both language and relatives to "his" growth, the name Jin Zhan was chosen to be deliberately ambiguous, as much a reference to place as to a person, according to the artist. In Chinese, enunciating "jin zhan" sounds like a pun on the word for "progress" (especially where the Chinese for "throwback" can also be translated as "a kind of regression").

The idea of messy growth then became a pointed reference to the chaotic way in which the environment of places across China is undergoing development. How much of this represents a forward motion is, the artist intones, up for debate. On the fringes of urban centres, where he continues to live and work, and where he clearly finds his greatest inspiration, transformation occurs with little concern for what existed before. Buildings get bulldozed. New ones are erected. Yet little of the physical substance or the spirit of community is improved.

In previous paintings, Li Dafang depicted this awkwardness in painstakingly detailed scenes taken from these suburban fringes as perfectly frozen instances from life. Each composition possessed an oddly absurd detail that blended in seamlessly until the moment its incongruity was spotted. It then became as much a source of perplexity to the viewer—what is it? Why is it there?—as of fascination to the artist impelled to place it there. This is one example of how Li Dafang makes his role as a painter function as a cryptologist, embedding vital clues to the future disaster that will be visited upon these environments into the compositions.

If the key to this new series of paintings was change, then it was also how change impacts the socio-psychological well-being of those who fall in its path. Li Dafang does not convey this by painting portraits of unhappy people—though many

◄ *Woman*, oil on canvas, 140 × 100 cm, 2012

147

Maluo Brothers' Bridge, oil on canvas, 260 × 390 cm, 2012

of his figures could be described as distressed in one way or another. Instead, where human forms appear in the pictures, they are almost incidental, as if cameos. It is place that is foregrounded, and it is exactly due to the tension created by the reversal of conventional scale between human and environment that the drama is heightened, and that the figures are fully suffused in a frigid cloak of futility, isolation and stasis.

The human forms are at once add-ons to the general scene yet essential to the achievement of mood and scale. They put the paintings into perspective, as it were, being the prism through which the intangible meaning of Li Dafang's scenes is made manifest. There is no absolute meaning to the paintings. Each composition is constructed of memories interlaced with fragments of stories and conscious and casual observations. Where Li Dafang's paintings succeed is that he makes the viewer feel what he wants to say.

The best of these paintings were monumental. One aspect of the artist's bucking pictorial convention was evidenced in the use of multiple canvases butted together, often at odd angles, to form broad physical spaces in which to map out the scenes. Of particular power was *Maluo Brothers' Bridge*, which projected an image of urban decay through a factory complex ensconced behind high walls in an old part of town, and *Deathless*, which depicted the cavernous interior of an industrial building, all apparently relics from a bygone era. Li Dafang has always known how to create an extraordinary aura in his works. If the compositions appear to present scenes from a drama, it is

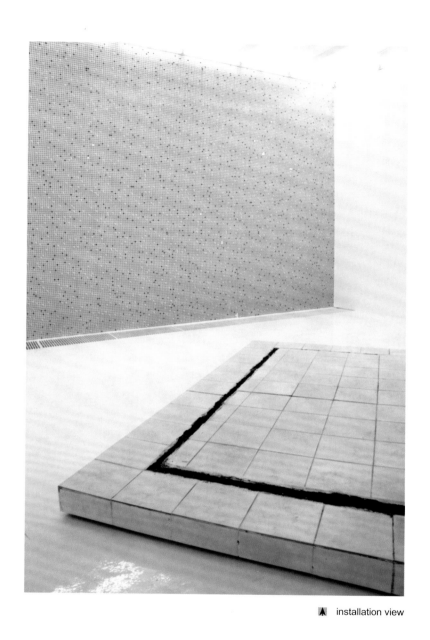

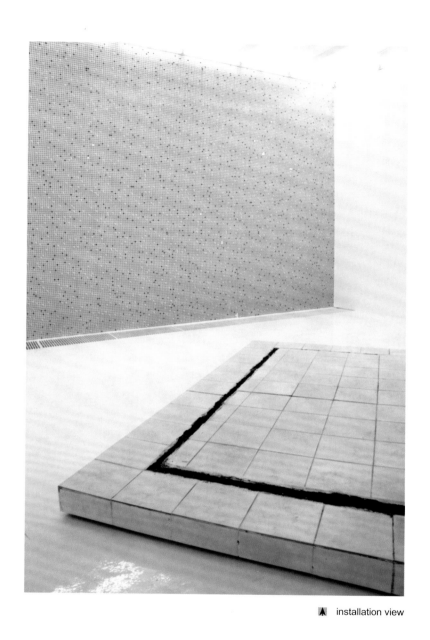 installation view

pictorial composition, making them feel physical, three-dimensional. And so you could walk around it and over it, stand on the floor, while staring at the wall, and ponder how hard it was to plot the random nature of the missing tiles; with your back to the wall you could appreciate the angles and trajectories of the floor. There were places where the floor and the wall visually overlapped as you moved through the space, which suggested that the orchestration could shift at any time: an optical illusion, ultimately, but one that was beautifully managed.

耿建翌 | Geng Jianyi

Wu Zhi

Hangzhou-based Geng Jianyi (b. 1962; Zhengzhou, Henan) graduated from the China Academy of Fine Arts in 1985.

Beginning in 1985, the year he graduated from what was then known as the Zhejiang Academy of Fine Arts in Hangzhou, Geng Jianyi was recognised as one of the leading artists of his generation, positioned at the forefront of what would—by 1990—be cemented in China's art history as the '85 New Wave; this date has come to represent the birth of the nation's emerging avant-garde. Continuing through the 1990s, whether at home or abroad, there was not a single survey exhibition of merit on the theme of the PRC's pioneering artists that did not include work from Geng Jianyi. He was, too, an instigator, leading a series of collaborations and projects to which he invited similarly experimental, innovative artists to participate. But then, as the new millennium dawned, it became less common to see his work in group exhibitions.

Solo presentations were also few and far between, the most important being Works From the Last 10 Years, which took place in 2004 and combined several groups of photographic works with drawings, rubbings and watercolour paintings (many of which were also featured in his 2012 show, Wu Zhi). Geng Jianyi's experimental work with photography was shown in Excessive Transition (Beijing, 2008), while a particularly successful intervention with objects and audience-as-participants was achieved with *Useless* (2004)—the latter a thoughtful massing of unwanted items, and one of Wu Zhi's centrepieces, offering a meditative reflection of consumer habits. We buy, we acquire; we use up and wear out, until said object is overtaken by a new model, thereby rendering the original possession redundant. Or we move and then never quite find a space for that thing in the new location. Kids grow up, we grow out of things, too, our tastes and habits changing as we ourselves do under the management of time. Useless was such a mesmerizing, ambiguous record of this process.

Geng Jianyi's distance from the public eye was not due to any change in his artistic practice—Wu Zhi revealed exactly how his work went from strength to strength as time went on. Instead, it was due to the inevitable side effects of his teaching

◄ *Four Interludes* (detail), infusion bottles, liquid, photo negatives, 2003

▲ *Ten Seconds Immersion*, thread-bound book, watercolour, 25 x 16 cm, 1999

responsibilities. In 2002, he joined Zhang Peili on the faculty of the New Media Department at his alma mater and promptly committed a huge amount of energy and time to his duties. He never stopped making works, however. As Wu Zhi demonstrated, under the paradigm he defined as his arena for art, Geng Jianyi included approaches that were uniquely distinct, which is also perhaps why they were less visible to a casual observer. Where these might take the form of documents, or combinations of documentary photographs and evidence of the processes of investigating suppositions, they were not always easily contextualised in terms of Geng Jianyi's broader body of work, or of "Chinese" contemporary art.

As the first comprehensive survey of the artist's work, starting in 1985 and ending in 2008, Wu Zhi was a major event. In giving vision and context to Geng Jianyi's career, for most visitors the exhibition was a complete revelation—almost as astonishing

Ten Seconds Immersion, thread-bound book, watercolour, 25.3 x 16 cm, 1999

as the collection of works on display here was the degree of surprise among visitors who, prior to seeing Wu Zhi, largely felt themselves to be familiar with the artist's work. Instead they were confronted with a rich volume of work—from painting to performance, photography and documents, installation to video—that was fresh, innovative and powerfully evocative of the artist's mindset, as well as of the times in which conceptual art in China came into being—largely due to the interventions of artists like Geng Jianyi.

His 1987 four-panel painting *The Second State* is one of a tiny handful of iconic works known even to audiences unfamiliar with the artist's name. Wu Zhi presented a double-panel-version titled *Double Happiness*. Viewers were able to follow the visual discourse through paintings from the early to mid-1990s, which bridged the transition to the rubbings and watercolour works of the later 1990s and the early 2000s. This was then a cue for highlighting the theme of identity that Geng Jianyi had begun to explore

A *36 Blows*, paper, mimeography, 23 x 18 cm, 1995

early on, but which was shown here in the 1994 interactive social study that he carried out in *Who Is He?* This comprised drawings and statements procured from residents in a housing block who had espied a visitor making his way to an apartment, and revealed the insidious nature of neighbourly scrutiny that existed at the time.

The combining of recorded human responses with photographs and formal documents could also be seen in *This Person* (1994)—reports on the fate of a friend of the artist, as collected from fortune-tellers after they were shown a photo of the individual in question—and *Definitely Him/Her* (1998-2012), which compared and contrasted the thumbnail portrait photographs of one person across multiple documents and ID cards. Identity remained a topic even in Geng Jianyi's approach to photographic portraits during the early 2000s, which were executed along similar lines evidenced in his mid-1990s paintings.

In their various ways, these compositions appear as portraits in conventional art-historical styles, but then subverted by, for example, dissecting the features with patterns of light falling on the contours of a face. In the photographs this was achieved

▲ *Overlapped Light Part*, double-sided watercolour and papercut assemblage, 19.6 x 21.4 cm, 1996

➤ *Useless* (detail), installation formed of unwanted 334 objects, dimensions variable, 2004

using techniques common to many of Geng Jianyi's experiments with photography, which returned to the physical properties of the photograph—light, and the chemicals that make transference of images from negatives to paper possible—used as drawing materials. The artist's preferred methodology was to draw directly on photo paper that had already been exposed to an image. In this way, contravening the reproductive nature of photography, each piece he produced was unique.

A similar approach was applied to turning ordinary notebooks into a dazzling array of unique artworks. For the Immersion series, books were soaked in pigment for an anointed time frame, their pages variously saturated with coloured ink or liquid paint, the subsequent patterns reflecting the absorption rate of the paper. And then there was *Offset* (aka *An Unapologetic Act of Sabotage*) from 2007, one of his video works,

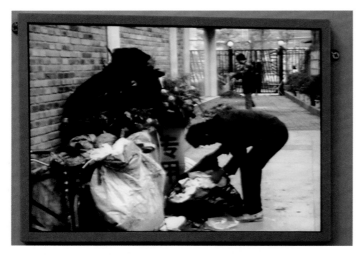

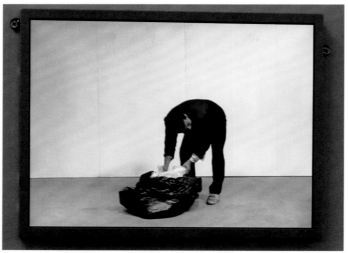

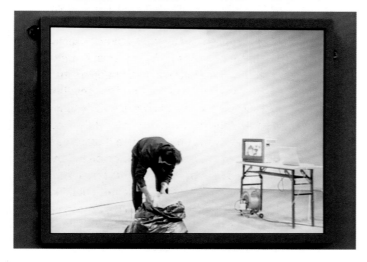

▲ *This Person*, photographs, drawings, fortune-telling cards, various dimensions, 1994

◀ *Do Yourself in a Right Way* (detail), colour four-channel video, 2005

shown here in China for the first time. Giving it context were four earlier collaborative video recordings, titled *Do Yourself in a Right Way*. Each of these had involved inviting ordinary people to review some brief footage of themselves engaged in their daily work: one sweeping the street, one painting a wall, another cleaning eels, while the last sorted trash. The four were then asked if they would reenact their actions, exactly as they appeared in the filmed sequence, but this time recorded by the artist in a studio.

 Do Yourself in a Right Way illustrated the complexity of these people's sudden awareness of the camera, of themselves, of how they might look on film, and their concern to act naturally so as to appear exactly as they had in real life. The sensations involved suffused the careful, measured pace of the final works, not least the intense degree of concentration of the performers in the throes of trying to be themselves in such an exact fashion. It was an enduring image of Geng Jianyi's vision for art: challenging awareness and involving the participation of people; lighthearted as much as serious; provocative—the brilliant reduction that visionaries achieve—confident, just focused on the idea. In illustrating the developmental relationship between various media and practices in Geng Jianyi's art, Wu Zhi represented the extraordinary knowledge and awareness of one of China's most important contemporary artists.

陈蔚 | Chen Wei

A Forgettable Song / Xian City

Based in Sichuan, Chen Wei (b. 1980; Zigong, Sichuan) graduated from the Sichuan Fine Arts Institute in 2006.

In Chen Wei's approach to art, either as pictures or installations, her works comprise multiple elements. Individually, the drawings and paintings suggest fragments of a bigger picture; as if viewers are being presented with the pieces of a puzzle. The exact nature of that bigger picture kept beyond immediate visual reach. In recent experiments, she has begun to focus on installation works, and of a scale quite at odds with her earlier work. In this new approach there is a relationship between the subject-matter she chooses to paint and curiosities from daily life. She handles this relationship well. It has become overly common for artists today to create clusters of small paintings and drawings, and hang them on the wall in suggestive spreads that hint at associations between the different individual components, as if these components are cryptic clues for a pictorial crossword. There was surely reason enough the first time an artist chose to suggest narrative using this kind of shorthand visual poetic. Increasingly, however, such groupings now seem to suggest more than they actually say, and have instead become easy—lazy, even—shorthand for the appearance of profound thinking.

Nevertheless, to mix materials and metaphors in this way does achieve a visual rhythm and a layered, spatial air of drama. That is the nature of Chen Wei's pictorial arrangements: in her groups, and attesting to the successful way she deploys this strategy, the individual painted forms function almost as elements mapped out in a Chinese ink painting. They have an internal logic and point of reference; of nature, for example, or of childhood (and suchlike), and we read them as we would a novella.

Chen Wei began working in this manner in 2004, while still a student, and a year before being nominated by Zhang Xiaogang for inclusion in the Second Triennial of Chinese Art in Nanjing in 2005. It was an auspicious beginning, yet more than half a decade then passed before her first significant solo exhibition in Beijing, All About

◀ detail of pavilions from the installation *Xian City*, moulded wire, 2011

▲ detail of object included in the installation *A Forgettable Song*, 2012
◄ detail of objects included in the installation *Xian City*, 2012

Her Songs, which took place at the end of 2011. The show in question contained a significant volume of work, which, despite the casual appearance given off by Chen Wei's use of discarded box lids and other such random materials to paint on, was two years in the making. The group was focused and intense. A series of pagodas, each individual piece drawn onto paper or card (or other more random surfaces), provided a particularly notable new departure. Drawn with pencil, ink, or collaged matter, these little assemblages of materials created miniature structures, linked together by threads and fine wires. The ensemble might have seemed simply decorative were it not for a subsequent installation, which she titled *A Forgettable Song*, in which the pagodas also featured and that teamed objects with painting, as well as small assemblages of carefully collated objects. As both *A Forgettable Song* shown in August and the reconfigured *Xian City* at the Ninth Shanghai Biennale two months later, this signalled a new direction, and a particular focus on daily life as experienced in China during the 1950s.

Nostalgia has become a marked force in art in China in recent years, and again whilst there is reason enough for its use by some artists, it has inevitably become a strategy too. Chen Wei's images, however, always felt as if they were related to the past—her past and her personal memories of events and experiences. In the case of both *A Forgettable Song* and *Xian City*, the past belonged to her parents. Understanding their personal history is Chen Wei's means of grappling with the complexities of the parent-child relationship in the face of what is, in China of this

168

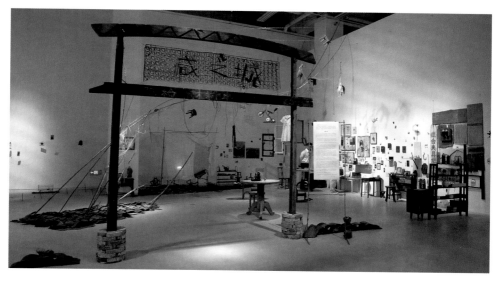

▲ *Xian City*, installation view, 2012

◄ detail of objects included in the installation *Xian City*, 2012

period, an unprecedented generation gap. These new assemblages were fashioned from various objects—from notebooks to buttons, pens to articles of clothing—that had been gathered from among her parents' possessions, as well as in second-hand markets. All bore the distinctive flavour of the 1950s; primarily utilitarian forms for the daily needs of the masses, as determined by the ideology of New China. The installation unfolded on a suitably intimate scale and was deftly controlled.

Both the form and substance of the installation could be paralleled with the early works of generational leaders such as the painters Qiu Xiaofei (b. 1977) or Jia Aili (b. 1979), particularly the latter's deployment of museum display cases containing documents and images from the past and the present, which serve as his inspiration. For Chen Wei, the association was not unimportant, for none of their generation can ignore the impact of change—hence the aura of nostalgia that has filtered through from their parents' mindsets to their own. And so both *A Forgettable Song* and *Xian City* said much about the formative experiences of Chen Wei's generation, and of the present, as of the past. Chen Wei is too young to have any reliable experience of the era she invoked, but not too young to be curious and fascinated about things she can only channel, or investigate through the physical remnants of that past. 'The object is only a carrier,' she says, 'an attachment of delicate or vulnerable emotions.' In her choice of title, *Xian City* suggests that, in approaching recent history in the manner of an archaeologist, Chen Wei's generation does not want to forget. So it digs with patient persistence, with the goal of piecing together reminders of the past, in the hope that what has been and gone can be uncovered, and to find the full picture—one that might approximate truths that may otherwise never see the light of day.

李松松 | Li Songsong

The One

Beijing-based Li Songsong (b. 1973; Beijing) graduated from the Central Academy of Fine Arts in 1996.

Three fundamental building blocks of an artistic training, especially for anyone learning to paint, used to be the mastery of colour, form and perspective. Attitudes towards these skills, and towards what exactly qualifies as mastery of them, have, through time, altered considerably. Once decreed to be essential for the creation of great art, the restrictive nature of their use that evolved – restrictions being the inevitable result of the practice of anything as it becomes set in stone, or placed on a pedestal – encouraged artists to confound traditional applications.

Groundbreakers, avant-gardists and rebels took these three "blocks" into their own hands—deconstructed and reinterpreted in the course of their search for new forms of expression. Still, for many artists, colour, form and perspective remain the key tenets of making art, which have to be encountered before they can be denied, experienced before they can be manipulated, and understood before they can be transcended. No longer are they an inseparable triumvirate, though. As separate entities, colour, form and perspective have each been the subject of entire artistic careers.

In terms of the style of painting that has become recognisable as being that of Li Songsong, the artist deploys paint in blocks of colour, where that colour is frequently directed to producing physical forms—meaning forms with a physical aspect, not just painterly descriptions of objects, or shapes, as realism—and the illusion of perspective achieved by means that are best described as a focus on surface texture. This was well evidenced in the painting installation *The One*—the single object of which this solo exhibition comprised.

Here, Li Songsong used colour to create multiple polygon forms within the interior of a twenty-four-metre-long tunnel, which combined together to achieve an astonishing, exaggerated example of perspective. Whether or not *The One* could

◄ *The One* (detail), oil paint on aluminium, 2012

▲ *The One* (detail), oil paint on aluminium, 2012

be understood as a subversion of the rules upon which art rests today was open to debate. Li Songsong is not known for an interest in artistic convention of any kind. He is a brilliant painter, who uses the medium to explore the sociopolitical history and contemporary framework of China, and of his times, yet in a manner that, while visually is simply gorgeous, still leads viewers to suspect that his attitude towards either the content or the form of his paintings—or both—is the subject of an inner conflict.

This suspicion is tied to the fact that the structures of many of his compositions appear driven by an urge to break or destroy the conventional picture plane. This he does not merely by breaking a work up into blocks of colour, but physically, too, using multiple and variously sized sheets of aluminium, or canvas, or wood, which are pieced together—at times overlaid or overlapping—forming the base upon which the ultimate picture is laid out and giving it the quality of sculptural relief. Aside from these many layered affairs, Li Songsong also breaks free of the picture plane by slathering paint over the surface of large, three-dimensional forms, often constructed of aluminium.

These thick layers of oil paint take months to dry, longer even, and have all the tactile appeal of a well-frosted cake. That was exactly the impression *The One* etched on the senses while walking through its twenty-four-metre-long tunnel. It was completely round—the interior a candy coloured kaleidoscope—a sci-fi tunnel, textured, faceted courtesy of ninety-one sections. Each protrusion and plane seemed to play a part in an elaborate mechanism, like the thickness and precision of a locking system.

The polygon shapes were covered with thick muffling layers of paint in great heavy blocks of geometric regularity. The cream-like paint surface was not exactly smooth; it contained ridges, pockmarks and air bubbles, on the scale of a segment specimen of something viewed under a microscope, magnified enormously such that every blemish in the paint is visible, like facial pores in harsh bathroom light, or like stone riddled with wormholes and living elements burrowed deep inside. The interior's

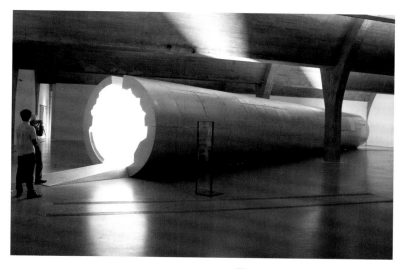

The One, installation view, 2012

illusion of perspective was enhanced, too, by the seams and lines that ran across the surface, this way and that, as the trace of the implement Li Songsong used.

The One was a work the audience could enter one at a time—twenty-four-metres long because, for the artist, that seemed exactly the right length for the experience he wished to create for the visitor passing through—thus was the full effect received. It was an effect that differed in darkness and in light, by day and by night. Darkness definitely enhanced the experience, if only to remove from view the guards at either end, watching anxiously lest someone bump into a protruding façade of paint, or poke the work with a finger. It also brought out the full depths of the pastel hues Li Songsong chose for the interior.

The layers of paint here were thick enough to soundproof the tunnel's interior, or, at least, to make the viewer keenly aware of their motion, and the sound of their breathing, as they moved from one end to the other. Within the embrace of the passage, visitors instinctively knew that such thickness of oil paint was not fully dry. How could it be when *The One* had been created ahead of the exhibition? The smell gave it away, too, making the journey fraught with an air of fragility. It was obvious that to touch any part would be to damage the delicate surface membrane irrevocably. That did little to diminish the urge to feel the mallow-like texture, giving rise to a heightened tension in the passage of those twenty-four metres.

The One was a painting primarily about the relation of colour to colour, and how tone and form create an illusion of physical reality, in this case that exaggerated perspective across a shorter than imagined distance. The structural elements that converged in the work walked that fine line between art and decoration, but didn't ever fall off. Li Songsong's work here was ultimately experienced less as an intellectual exercise concerning practical theories of art and instead as the embodiment of sensual indulgence.

The Secret Garden I Reevess Pheasant

胡昀 | Hu Yun

The Secret Garden / Reeves's Pheasant

Shanghai-based Hu Yun (b. 1986; Shanghai) graduated from the China Academy of Art in 2008.

In 2011, Hu Yun spent three months in London as part of an artist residency programme that saw him seconded to the Natural History Museum. This was part of an initiative to invite artists into the museum and allow them to respond to natural history by giving them access to the collection. The emphasis was on studying an area of the collection related to the artist's own geographical origin—China in Hu Yun's case—and to create a work using what was learned during the research period.

For Hu Yun, this process set in motion a chain of presentations—both delicate and subtle (his works are frequently characterized by these qualities)—based on his findings concerning the historical connections between China and Britain, specifically those made through the channels of nature; on the British side, born of the Darwinian obsession with the discovery and identification of new species (and the missing links needed to perfect the chain of evolution). Not least, the eccentricities of Victorian Britain, evidenced in the men who ventured out to China in the name of discovery, and who settled—during the specific period that Hu Yun chose to explore—in the southern treaty port of Canton, today known as Guangzhou.

Victorian Britain was, at best, an age of extraordinary general curiosity about the world; at worst, of misguided do-goodery. In the middle lay the machinations driven by ambitions for trade expansion. It was this form of "discovery" that extended the bombastic adventuring of the early colonial era, when Britain claimed India. Hu Yun's focus took its direction from a large collection of illustrations on the botanical richness of China, paintings completed in the vicinity of Guangzhou, commissioned and formed by British naturalist John Reeves (a tea inspector for the British East India Company, who devoted his leisure time in Canton to documenting the different specimens of plants and wondrous animal life that he found there).

◄ *The Secret Garden / Reeves's Pheasant* (detail), installation, dimensions variable, 2012

▲ Detail of the Reeves's Pheasant feathers as
featured in an opera costume, from a video clip
included in the installation

◄ *The Officer's Desk*, mixed media, objects, 2012

The skills brought to these botanical and zoological illustrations, painted not in oil, but in watercolour, or Chinese mineral pigments, are astonishing. All were produced by local artists, and while distinctly Chinese in being impressions of each individual bird, fish, flower or shell, rather than scientific diagrams, they appear to capture the very essence of the natural world, fused with a breadth of life. Almost none, however, bear the name of the hand that produced them. And yet many of the new specimens found would reward the foreign adventurer-discoverer with the use of his name (while the artisans remained anonymous). John Reeves, for example, had twenty-seven species named after him, including the Reeves's Pheasant, and the subject of Hu Yun's work, *The Secret Garden: Reeves's Pheasant*.

The Reeves's Pheasant is, quite simply, gorgeous. It is no wonder that John Reeves felt impelled to introduce this unusual bird, native only to China, and with no known subspecies, into Britain in 1831 upon his return home after twenty years in China. This particular type of pheasant has the longest tail feather of all the world's birds—a fact long known to Chinese opera performers, who used them to decorate the hat of a particular operatic figure, immediately recognisable by his headgear with its gracefully flowing feathers, and which he parades during the opera in a specially choreographed scene. This was shown here in Hu Yun's installation, in the form of a video clip extracted from the full-length opera (like a bird plucked from its natural habitat), and shown on a monitor placed on the floor of a glass enclosure, such as one might encounter in an aviary or zoo.

The Secret Garden aimed to create a space covering every element related to the essential features of a naturalist's work, which is to say John Reeves, and the captivity involved in gathering specimens to be transported from one home to another. And so Hu Yun reconfigured the physical area provided for the installation to the exact shape of the aviary in which Reeves first saw the pheasant (the aviary of a wealthy bird fancier in Macao). That configuration was also illustrated in the form of a model aviary, a miniature version of the space in which the audience stood, placed on a plinth. This referenced both the actual place in which Reeves first saw the pheasant and the bird's

Beale's Aviary, detail of the aviary in which Hu Yun imagined Reeves's first encountered the pheasant.

final destination once it arrived on British shores—a life in captivity inevitable.

Next to the model aviary was a wooden crate, of the kind in which you'd imagine a zoological specimen to be transported, neither overly large nor suffocatingly small; it was essential that the specimen arrived alive, and thus the crate was suitably punctured with breathing holes (sealed with gauze so that nothing could get in and nothing could escape). Adding another layer to the references here, Hu Yun chose to use the exact proportions and dimensions of the crates used by the East India Company to import opium into China at the very same time as Reeves was shipping the nation's wildlife out.

Finally, in the far corner was a beautifully envisioned and crafted "desk", imagined for the naturalist when engaged in his studies, littered with images of birds' feathers. An extraordinarily delicate watercolour painting, which had been used to create a patterned wallpaper could be seen on the wall behind the desk. There was also a perfectly authentic map, such as Reeves would have used to identify the origins of his species, this one cut through in the manner Lucio Fontana applied to canvas, but in the shape of the pheasant—a red cut, also like an Anish Kapoor Wound, and thus poignant, both symbolically and metaphorically.

All in all, *The Secret Garden / Reeves's Pheasant* was a marvellous and well thought through work, which gained myriad nuances from being present in the current age, when China's status is so different, and the nation less ripe for plucking at will, as

🔺 *Chest of Curiosities*, detail of the crate in which Hu Yun imagined the Reeves's Pheasant was transported to Britain.

was once deemed the case. Then there was the fact that it was on show in the city of Guangzhou where the story of "Reeves's Pheasant" began. Despite all the complexities of the opium trade, of the damage that was done in its name, in terms of botanical and zoological progress, Reeves did the world at large a tremendous service, as he did, indirectly, to China's wildlife. From whichever point of view, from China or from the West, from both then and now, *The Secret Garden / Reeves's Pheasant* pointed viewers to issues of value, of care, of dedication and patience, of preservation and commitment—all of which are today rarely accorded such devotion in art, or in natural history in general.

郑国谷

Zheng Guogu

Spirits Linger With Dust

Yangjiang-based Zheng Guogu (b. 1970; Yangjiang, Guangdong) graduated from the Guangzhou Academy of Fine Arts in 1992.

In this post-postmodern age, art may be thriving, but with no single theory to steer it (or to react against), the message embedded within an artwork can be hard to appreciate. In the face of a democratic multiplicity of all-inclusive positions, artistic expression today often feels directionless. The prevalence of possibilities confounds some artists— those who need to know what to push against before they can see an artistic angle that gives them an "in". Self-reliance is seldom easy, especially when art is increasingly governed by the places in which it is seen: art fairs replacing gallery-going; private museums competing with public institutions as a focal point for artists and viewers alike. This phenomenon may have its attractions, nonetheless, being adrift from the system, commercially oriented as it is, is a distinctly unattractive prospect for most artists.

The point of this rumination is the artist Zheng Guogu, whose approach to making art is an exception that proves the rule. Owning something in common with the position electively adopted by the artists Gu Dexin and Geng Jianyi, who both emerged in the 1980s, the distinctive contribution that Zheng Guogu has made to contemporary art in China since he emerged in the mid-1990s has been achieved with little effort on his part: all his energy has been directed towards the process of carrying out the urgent impulses that drive his art, leaving the rest to just happen. Further, since his initial brash expressions in the mid-1990s, which began with the medium of photography but didn't stop there, Zheng Guogu has not only pursued his multiple interests in the seclusion of his studio, but at a significant distance from even the nearest art hub of Guangzhou, electing to remain in his native Yangjiang, a mid-sized town three hours (and some 150 miles) southwest of Guangdong's capital.

In recent years, within the gallery circuit, or other exhibition spaces, Zheng Guogu has been less visible still, though highly active in Yangjiang where he has

◄ *Grand Visionary Transformation of the Six-Armed, No.1* (detail), oil on canvas, 184.5 x 137.5 cm, 2012

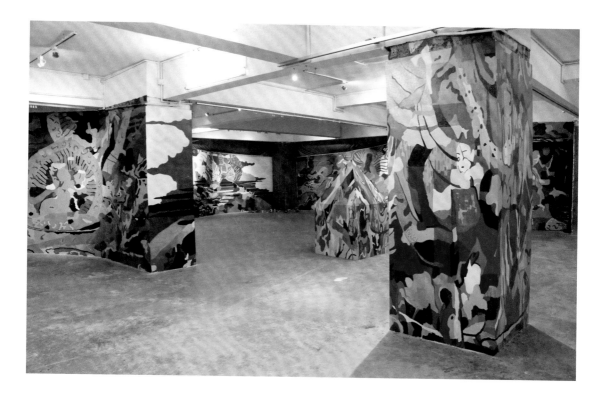

devoted his time to building an empire—literally; it's no joke—on a swathe of farmland purchased illegally from a farmer. That extraordinary project is a story all its own. The point of mentioning the overwhelming volume of positions in art today is that confounded artists often retreat into pre-postmodern values—scale, intricacy of image and meticulous execution—finding them a comfortable (if not entirely familiar) refuge. Those elements may no longer entirely carry an artwork as they once did, but a piece in which all three are pronounced commands authority as well as attention.

The work under discussion here is a full gallery-sized mural that Zheng Guogu completed in September 2012; walking into its embrace achieved the desired impact. Floor to ceiling, wall to wall, even wrapping itself around pillars in the space, *Spirits Linger With Dust: Untitled* was mesmerising. That it was a work by Zheng Guogu countered any sense of it being an exercise in decoration alone. This particular piece followed on from a series of paintings, normal-sized canvases for the most part, which Zheng Guogu began in 2011, exploring the structure and motifs of Buddhist mandalas— the visualisation of spiritual spaces, which are shorthand representations of a world view or cosmology that positions the realm of men vis-à-vis the heavenly paradise humankind seeks to attain. Never considering himself a painter, nor specifically preoccupied with painterly concerns, for Zheng Guogu the manipulation of the mandala has been a reflection upon 'the local context of a specific space and a specific moment in time', in the manner that 'humans react to different circumstances by going with the flow.'

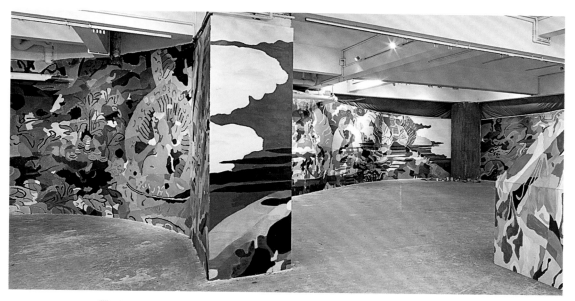

◄ *Grand Visionary Transformation of the Six-Armed, No.2* (detail), oil on canvas, 187 x 138 cm, 2012

That was illustrated on an intense scale in this ambitious mural, which covered the entire wall area of the gallery; content followed theme as an extrapolation of typical mandala imagery, yet this was not an exercise in abstraction. In the manner in which a mandala is structured, so there was an internal logic to the flow of the forms that dictated the mechanism of its evolution around the walls; a precision about what colour went where and into what shape. The work extended to every façade and owned a trajectory that ran up through the ceiling and out onto the roof, to form a "hat" on top of the building. Thus *Spirits Linger With Dust: Untitled* represented an imagined but impossible transition of the work through space; the brain registered the pattern and connected the dots. Following a series of collaborative paintings that Zheng Guogu has been involved with in Yangjiang, this mural was not the effort of his hand alone. It was completed over the period of a month with the help of approximately fifty local artists.

Zheng Guogu is no stranger to collaboration; even the early photo works from the series he titled Youth of Yangjiang relied on friends to pull it off – they were themselves the "youth of Yangjiang". In recent years, working under the banner of the Yangjiang Group, he has participated in a series of works exploring a particular Chinese cultural phenomenon, namely the writing of poetry and prose as calligraphy, inspired by the warm exchanges of intimate friends—other members of the Yangjiang Group— and lubricated by copious volumes of alcohol. *The Garden Project* is perhaps the best known of the artistic outcomes; an installation comprising various objects and reams of calligraphic text that have been solidified under a layer of candle wax. There is a relevant point of comparison between that project's appropriation of Chinese calligraphy and Zheng Guogu's approach to mandalas, too, for in invoking an established cultural phenomenon, he has a succinct knack for giving it a powerful new spin.

刘韡 Liu Wei

By Order of the Artist: No Title Necessary

Beijing-based Liu Wei (b. 1972; Beijing) graduated from the China Academy of Art in 1996.

Towards the end of 2011, Liu Wei was heard to say that he intended to insert a pause into what had, in recent years, become a relentless pace of artistic output. He had come to the end of the road, he felt, of the ideas that had driven his art through a tumultuous half decade in which each piece—specifically the large-scale structural installation works that he began around 2008—was more impressive than the one preceding it. That is not an easy feat to achieve. Putting the challenges of aggrandising scale aside, along with the complexity of structure, which he continues to relish, Liu Wei seemed to have discovered—come the conclusion of 2011—that the ideas behind the forms were no longer as compelling as they had once been.

Experiencing the physical presence of the assorted structures that made up a portion of his 2012 solo exhibition, the dissipation of force was palpable. Separately, or as a whole, these structures—a collection of steel bars and steps adjacent to the circular "arena" from which the audience was excluded (it was necessary to climb the steps in order to catch a glimpse of its interior)—were lacking in a sense of cohesion. They felt big because they could be, without the qualities that had made previous structures, in the vein of *Merely a Mistake* (2010) or *Don't Cry* (2011), so successful.

Through the same period, Liu Wei's paintings, too, had evolved from the graphic digital logic of what had been an ongoing series of urban cityscapes, into thick smooth-smeared layers of dense oil paint. The colour had switched palette from bright chemical pigments to sober, blended hues. As seen at Art HK 2012 in Hong Kong that May, the new format was abstract, the compositions simplified to consist of a line or two, and a small number of rectangular blocks—as if a magnified section of an urbanscape over which winter had fallen. Far from desolate, these were haunting, moody works, which

◄ *Untitled*, canvas on steel frame, 300 × 180 x 15 cm, 2012

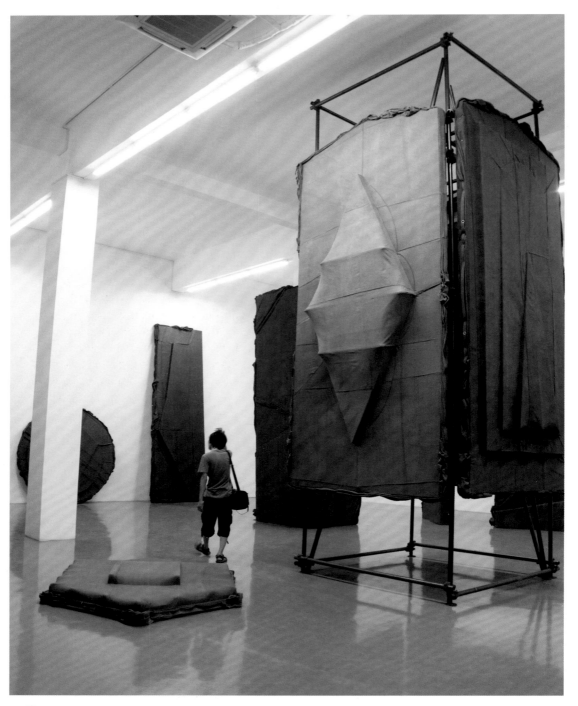

▲ installation view

were nonetheless rich in timbre: all qualities that Liu Wei successfully transposed onto the canvas-covered structural works that formed the intensely memorable portion of his show.

The exhibition was not given a title, ditto the works included, because Liu Wei 'insisted that there was nothing to be said in words'. Ah, so where does that leave me? And what does it imply for the prognosis I might give? In the context of Liu Wei's intention to take time out to rethink his direction, it was something of a surprise to see this solo show, and, moreover, stunning to see works that were both new, in terms of innovation, and strong, in terms of the powerful presence they exuded. The works in question were large; at times, huge. Each construction consisted of a steel framework, over which an expanse of heavy duty industrial canvas, thick and tough, had been stretched. Yet not stretched in the simple and even manner that a painter requires, but instead following—almost—a Rick Owens-style of folding, ruching and overlaying pieces of cloth, thereby creating form through the warp and weft at competing angles, introducing seams, almost as in patchwork but where you'd least expect them.

They thus attained a three-dimensional twist to what was otherwise a flat picture plane; multiple planes all facing this way and that as facets of a work that thrived on the scale and blankness of the facades. Again, similar to those minimalist paintings, the blankness here was made rich and more by the texture and tonality of the humble sackcloth. Humble it might have been, but nuanced with painterly subtleties from the varying hues of the fabric. These variations were slight: of the same brooding timbre as the painting mentioned above, and in the vein of old navy blue, all the shades of army-type greens, air-force grey and neutral beige. And yet these expanses managed to be as expressive as a Rothko—think of those paintings in the Rothko Chapel in Houston.

In the dullness of the tones, there was a suggestion that Liu Wei had bought up the remaining rolls of unwanted material left in a store, through time faded by sunlight, or washed out by the penetration of dust. The natural association of these colours with the military was, one suspects, not a random choice. Liu Wei understands that, as physical structures, installations have the potential to control the environment in which they are placed and, through that placement, exert an insidious force upon those who encounter them. Visitors here were dwarfed by the magnified scale of the individual components, which loomed up at them, blocked the space ahead of them, dictating not only where the visitor could go, but how they felt while shepherded through this impressive and oppressive arena.

The experience was altogether rather awe-inspiring, each component of the installation being hefty, brute in a way, as a room full of marines might well be. This cogent sensation was well asserted by the coarse textures of the cloth, its practicality, its bulk, and the deliberate neatness of all those folds, idly mimicking the care soldiers must show for their uniforms and when making their beds. The canvas works were, then, an experience worth having by any standard. The approach seamlessly blended almost every strand, to date, of Liu Wei's artistic experiments with form, texture and structure as a vision of control, power and manipulation of all who come into contact with them. For all that Liu Wei could not say in words, this collection of objects was a truly notable achievement.

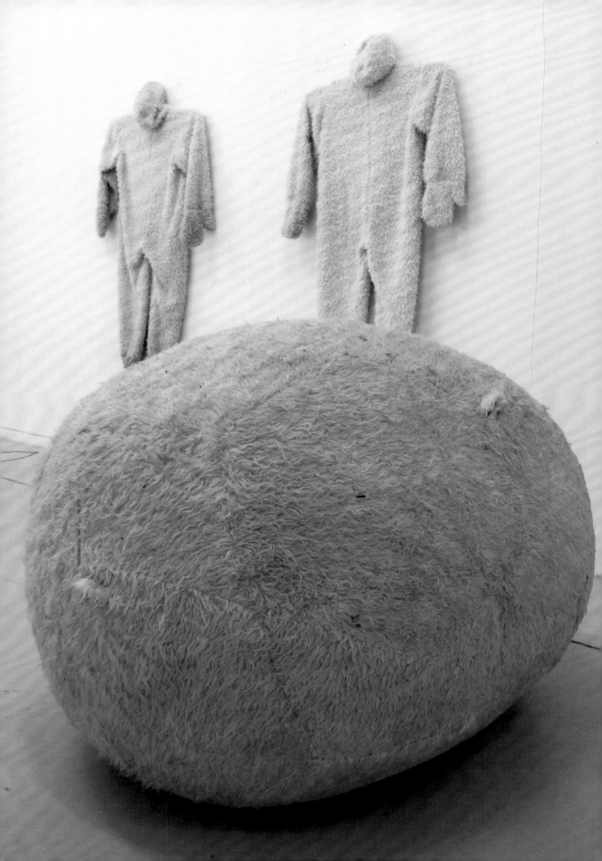

乌托邦小组 | Utopia Group

Trudge: Geography of Utopia Group

Utopia Group (b. 2008; Beijing) consists of Deng Dafei and He Hai. Deng Dafei (b. 1977; Jinzhou, Liaoning) received a BA in Art Education from Northeast Normal University in Changchun, Jilin, and a MFA in 2005 from the China Academy of Arts in Hangzhou. He Hai (b. 1974; Zhengzhou, Henan) received a BA in Graphic Design from the Beijing Institute of Fashion Technology; a MFA in Fine Art from Donghua University in Shanghai; a doctorate degree in Visual Art from the University of Strasbourg in France in 2011.

Group activity in China has recently experienced a surprising resurgence; surprising, given the accent on individual careers in art in China today, and because its last heyday was in the mid-1980s under rather different socio-political and cultural circumstances. None of the young artists involved in the new phase of group activities has direct experience of the impulses that impelled their predecessors in the 1980s or, due to the on-going lacuna that is the field of local art history in China, more than a cursory knowledge of the kind of manifestos that were invoked back then. As surely as history repeats itself—a subject that Utopia Group has tackled in several projects produced to date, as witnessed in Trudge— so, too, does the youthful idealism that is a prime mover impelling the formation of groups at this time. As is demonstrated by other entries in this book, for the artists involved the group dynamic is a force both liberating and inspiring. The kind of creativity it delivers has vitality and power. Additionally, as in the case of Utopia Group, humour exists as a satirical edge to the madness they explore as art.

The activities of Utopia Group date to 2008 and were launched with a year-long project titled *Family Museum* in Shanghai. When the group formed, its two members Deng Dafei and He Hai were living in different cities (Beijing and Hangzhou, respectively). Beginning with that first project, it has been the opportunities afforded by artist residency programmes that have created situations under which the pair can come together and can execute specific, often ambitious projects. Where the practice of artist residencies is more established abroad, the number of Utopia Group's projects realised overseas is proportionally greater than in China, which has in turn contributed to the content, approach and format of those collaborations.

From the first, the artists' goal was to take art out of its usual haunts and to an extended segment of the populace that might not be museum-goers. Nothing new there

◄ props used in the making of the video *Enclosure*, 2011

▲ map created for *Enclosure*, ink and paint on sheepskin, 180 x 220 cm, 2011

perhaps, for that kind of idealism belongs to every artist in the early stage of their career, but there is an energy and viewpoint expressed through Utopia Group's actions that aligns them with a contemporary interpretation of what art can do within society today; or what can be done in the name of art, and which is linked to the past, to a place or to a specific historic attitude of a culture. If Utopia Group's idealism is as yet undiminished, it is because the reception received from their targeted audiences has been enthusiastic and positive.

The exhibition Trudge pivoted on the debut of a recent work titled *Enclosure* to domestic audiences and, at the same time, put it in the context of several previous social performances that were realised between 2009 and 2011, and a new work. The choice of title seemed to indict the challenge of taking art out of its institutions: "trudge" suggests a laboured motion, the toil that is required to create something from nothing, be that a career or an artwork, and to push against the odds and against obstacles which arise outside of those conventional art spaces to which visitors go willingly. Taking art beyond accepted art spaces inevitably involves confronting people who do not necessarily chose to make culture a part of their daily experience and who may well object to a forced encounter. Yet, as evidenced in this exhibition, Utopia Group's journey thus far has unfolded smoothly enough; at least, without a dull moment.

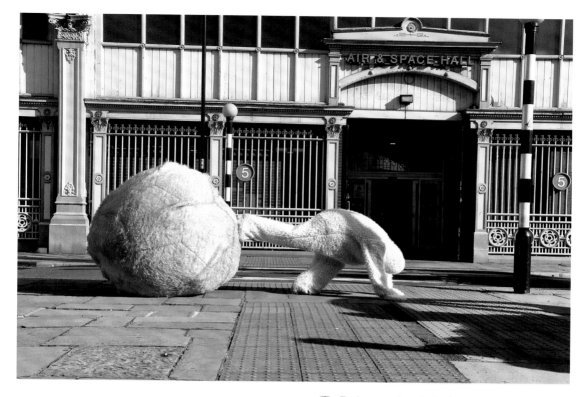

A *Enclosure*, colour single-channel video, 13', 2011

➤ map created for *Dark Utopia*, ink and paint on paper, 210 x 300 cm, 2012

As a centrepiece, *Enclosure* extended an approach Deng Dafei previously used for the video work *Astronaut of Shenzhou Spaceship No.19* (2004), which followed the artist, dressed in a bizarre spaceman outfit and walking backwards on all fours through an urban landscape, kicking a large black sack as he did so. Although different in its point of departure, Enclosure had similarities to *Astronaut of Shenzhou Spaceship No.19*'s visual format, primarily in the unusual suits worn by Utopia Group members—man-sized fury white bunny suits on this occasion—and the manner which precipitated their journey through the streets of Manchester in the UK: "walking" on all fours backwards, pushing a giant ball of wool before them. This was one instant in which Utopia Group's approach to art and the inherent issue of forced encounters with a largely non-art audience represented a brave move; Manchester being a city in which dressing as a rabbit was a definite challenge to social norms. In the event, the huge ball dominated readings of the artists' action; the awkward backward-kicking motion was taken by some observers as a mockery of the local football team which, in this context, was a distinctly challenging message for art.

Invited by the Chinese Arts Centre in Manchester on the occasion of the 2011 Asia Triennial, *Enclosure* was, in terms of using wool and of the labour the artists put in hiking the ball through the streets, a reference to the Industrial Revolution as an

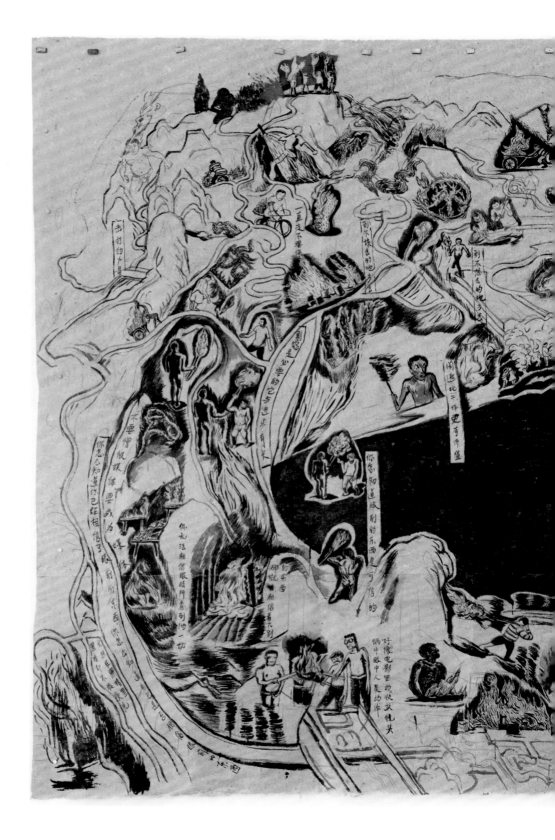

196

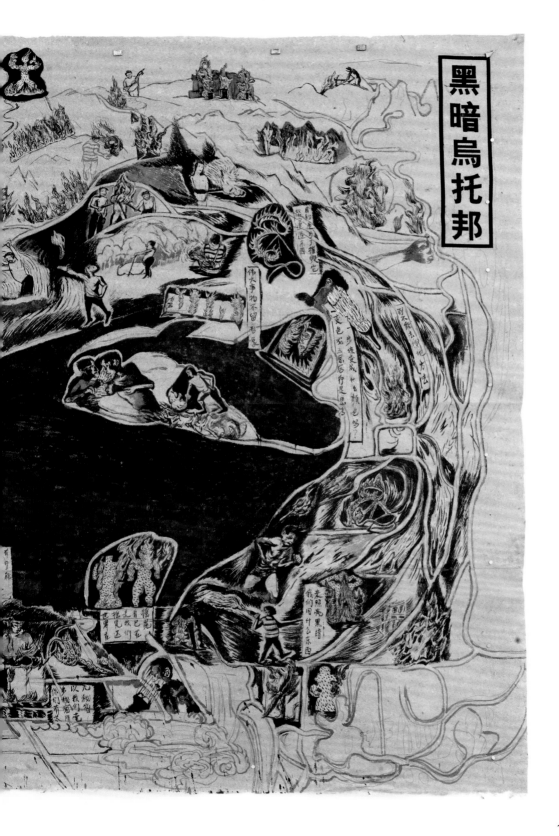

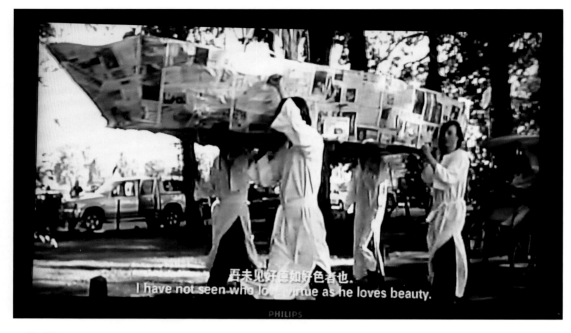

吾未见好德如好色者也.
I have not seen who loves virtue as he loves beauty.

PHILIPS

A ➤ stills from *Palace of Puzzles*, colour single-channel video, 2009

event integral to Manchester's history, albeit a period that occurred two hundred and fifty years earlier, and, excepting the relics of the red-brick factories which once housed said industry, one with little residual evidence visible across the urban landscape of Manchester today. In being a phenomenon of which Utopia Group was consciously aware, *Enclosure*'s reference to the Industrial Revolution was more a mirror to China's on-going socio-economic rise and increasing command of many of the manufacturing industries that once shored up the Mancunian economy. The complexity of that issue was deflected in the exhibition: too weighty to be carried by the two empty fury suits now hung on the wall, and a deflated-looking ball.

In the context of Trudge, Utopia Group was then seen in Scotland, giving full vent to its capacity for mad invention in a project titled *Palace of Puzzles*, inspired by the Scottish Sinologist James Legge (1815-97). A native of Huntly, where Utopia Group spent three months researching his life and legacy, Legge today remains one of the foremost Sinologists known to the Western world, a significance that lies in his translation of twelve dauntingly complex volumes of philosophical writing from China's most respected classical thinkers. Utopia Group elected to pay tribute to these achievements in the form of a funeral procession: one which through a combination of Chinese elements transformed the usually sombre Western tradition. The final event looked and felt more like a carnival; a blend of 'tragic elements and comedy elements', which, according to the artists, may have seemed 'absurd', but that in being one of 'two happy things' in China—the other being marriage—'obeyed the rules of nature'.

The video of the event is fascinating viewing. A large gathering of members of the local Huntly community swathed in white sheets, waving calligraphic banners, and

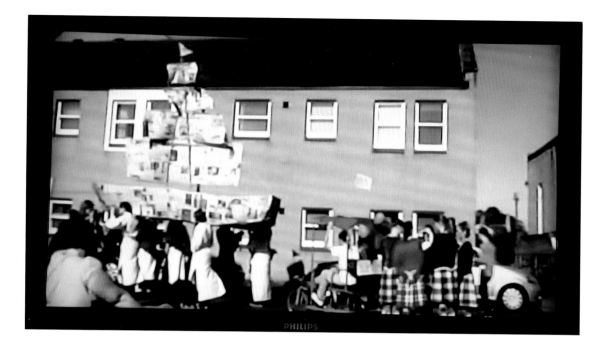

PHILIPS

ambling amiably in rambunctious order behind the artists, who shouted nonsensical phrases and slogans through handheld megaphones. The procession—including two noble dray horses pulling a cart, highland dancers and Scottish pipers in full regalia—culminated in the ritual burning of a boat made from newspapers and carried in the manner of a coffin bier as part of the procession to its point of cremation on a riverbank.

Similar to other video works shown here, what made *Enclosure* and *Palace of Puzzles* come alive was the prevalence of drawings and objects created either in the course of mapping out the projects—and indeed many of the drawings were maps themselves—or that formed part of them. A fine example was the newer work, *Dark Utopia*; to quote the artists a 'concept of a utopia with light and darkness, and a fable about a flame dashing towards the darkness'; the artists created a 'mind map' for the work, a place they described as 'fictitious geographically, but real in the mind'.

Illustrating the inventiveness of Utopia Group's process, the description of this map cites the 'dark block' in the centre as representing 'the origin of darkness and nothingness; the ancestor of the world'. It describes the video, created using the map as a guide, as being 'filmed in Dongba, a suburb of Beijing, which is a typical mixed area between the urban and rural . . . dirty, chaotic, noisy and full of dilapidated buildings, cheap goods and dirty restaurants.' It sounds convincing, but Dongba is a figment of Utopia Group's imagination. Nonetheless, all of these elements were beautifully and convincingly inscribed on the map. In giving its own take on the concept for the exhibition, Utopia Group wrote 'the wonder of "trudge" lies in its magic combination of daily routine with ideal.' That much was clear in the fine examples of works presented in this exhibition which, in combination, amounted to a sum more magical than its individual parts.

周轶伦 | Zhou Yilun

Our House by the Seashore

Hangzhou-based Zhou Yilun (b. 1983; Hangzhou) graduated from the China Academy of Art in 2006.

As described in *As Seen 1,* Zhou Yilun continues to be a crazy painter. He is also still prolific, and it's yet hard to tell if that is an entirely good thing or if it might, at times, be slightly problematic. He routinely manages to produce spectacularly good works, but there are often, too, a slew of mediocre ones to cast aspersions on the issue of whether the dynamism he brings to painting is in the realm of genius or not. The conclusion thus far in his career has to be almost, but not quite yet.

His 2012 solo exhibition As There is Paradise in Heaven was the first comprehensive showing of his work to date. Some people will choose to disagree with that view, perhaps citing earlier exhibitions in other exhibition spaces, but the effort the artist himself exerted in curating and hanging As There is Paradise in Heaven gave the show an undeniable cohesion. Zhou Yilun had clearly devoted to the positioning and combination of works here careful deliberation, even when that positioning was—as is his style—best described as artfully anarchic, and even where, on occasion, brilliant pieces were put next to rather less impressive ones. In terms of unusual approaches to display, there were casual stacks of differently sized paintings, bent canvas stretchers that lifted themselves off the wall at disturbing angles, and pieces with extramural flourishes that extended beyond the paintings to the wall and other works. But for me what stood out from all the studied dynamism of the hang was a three-dimensional structure titled *Our House by the Seashore.* This took the form of a small house, as referenced in the work's title; one that, on first encounter, paralleled the fantasy of those found in myriad children's fairy tales.

Our House by the Seashore was, to be clear, an adult house in terms of themes and structure. Its four walls were made up of four pictorial artworks, one of which— *I Want to Display it in Our House by the Seashore*—lent its name to the assembled

◄ detail of *Untitled*, thread on fibre bed base, wood frame, 190.5 × 134.5 cm, 2012

🔺 *Our House by the Seashore*, mixed-media installation, 230 x 192 x 150 cm, 2012

▲ *I Want to Display it in Our House by the Seashore*, oil paint on fibre bed base, 148 x 192 cm, 2012

structure. The images Zhou Yilun combined here were daubed on bed bases, as pictures on the lattice weave strung across the bed frame. These frames were of a traditional and practicable form commonly seen and used in the Zhejiang/Jiangnan region where the artist grew up. Thus, across a simple and sturdy wooden frame was a woven "thatching" of coarse hemp fibres upon which the mattress would have gone.

In wealthy homes, these beds would have been so much grander, the weave made of cane not hemp, and very much finer. But such refinement would have been totally unsuited to Zhou Yilun's creative purposes. The artist had used the herringbone web of fibres as if it were a loose-weave Herta fabric—the kind given to children to facilitate the learning of embroidery (relevant because two of the four images here were created using that very technique). While Zhou Yilun made great sport of the childlike

methodology brought to his chosen form of appliqué, the simple appearance was—as in most of his works—craftily deceptive.

To follow the point raised in the exhibition's title about human attitudes towards the entity we call heaven, the subject of Zhou Yilun's main embroidery was a Madonna and Child. If there's one thing most people agree on it's that heaven is where good people end up after their time on earth; heaven as the ultimate paradise. That promise was suggested in the beatific smiles of Zhou Yilun's Madonna and Child; both figures, a web of stitches of brilliant simplicity, radiated happiness. The Madonna was like a healthy pink Botticelli Venus, the robust child in her arms the very image of a cherub. But as with so much of the imagery Zhou Yilun presents, the vision was equally a perfect parody, a holiday snapshot of a mother and her young toddler, on a beach, by the seashore, where this house would be at home—a house by the seashore being, for many of us, the very embodiment of heaven on earth.

On the opposite end of the house was a similar brightly coloured embroidery of a "parent and child", this one of a more ambiguous nature, the child blocked out in heavy black thread and with an unexplained homuncular physicality. Retaining some suggestion of play with classical paintings, just around the corner on the house's widest exterior face was the titular oil painting *I Want to Display it in Our House by the Seashore*, painted on a finer weave, but of an equally rough texture, which imbued its figures with a primitive air. The composition depicted a male (bearded in a red-headed Jesus kind of feminine-masculine way) and a female standing side by side, engaged in an act of intimacy, which the viewer had interrupted. The hand of the figure on the left rests on the female's breast, making some slight allusion to the classic sixteenth-century European painting of two sisters in which one tweaks the other's nipple (*Gabrielle d'Estrees and Her Sister, the Duchesse de Villars* by an unknown painter). Here, viewers were equally unsure of how to read that gesture, especially in relation to the "it" in the title, which the "I" wished to see displayed.

The fourth picture on the final exterior wall was a translucent, watery, black and white portrait of a shirtless male; positioned next to the entrance, he felt like a kind of bouncer, watching over the comings and goings within, for tiny as it was, it was possible to enter into Zhou Yilun's house. There was little to see inside, however, beyond a delightful and rudely upturned fairground rabbit whose orifices had been reassigned as a water fountain. There was also a chair, and a small number of sculptural figures pinned to the walls. Although form and ideas were deftly married in all aspects of *Our House by the Seashore*, the real gilt was to be found on the exterior surface.

胡晓媛 | Hu Xiaoyuan

No Fruit at the Root

Beijing-based Hu Xiaoyuan (b. 1977; Harbin, Heilongjiang) graduated from the Central Academy of Fine Arts in 2002.

Hu Xiaoyuan provides a maximum emotive force for the viewer via a minimum of factual information for them to draw upon in their reading of the image. When it comes to achieving a deception of viewers' senses, this artist finds her most effective means in the apparent reality of the things she presents to her audience using video. An exacting example of this skill was found in the 2012 work *Drown Dust*, which illustrates quite perfectly the manner in which Hu Xiaoyuan presents something—an act or an object chosen to convey the impulses that encouraged her to make the artwork—and then obfuscates it entirely. What is seen becomes something other, the actual substance rendered invisible, like a gift given with one hand and taken back with the other. Yet the experience of viewing her video works is by no means as frustrating as it might sound. Nor does it leave the viewer with any sense of having been cheated or denied.

Hu Xiaoyuan's work has always been subtle, especially in her choice of delicate materials and minimal content, with an aura that is quiet. In recent years, almost all examples of her work seem to exist to deny what they are, either as the content of her videos, or in terms of the physical substance of materials she brings to the objects. The video installation *See*, 2012, was the ultimate illustration of this duplicity. From the first, it challenged the patience and diligence of the viewer's engagement with it. Gazing in anticipation at a white, apparently blank screen, it was easy to give up on See and pass along to the next exhibit. Even if the eye registered the fine, faint vertical line that could just be seen moving horizontally across the screen, from left to right and at a slight slant, the brain may easily have read it as being electrical interference, and nothing more.

The line was, in fact, produced by the artist, concealed behind a drape of white paper, moving that column of paper from left to right, and relying on the motion of her body to carry that fragile cargo evenly, continuously, and imperceptibly, as if a curtain gently

◄ *See* (detail), two-part video installation, dimensions variable, 2012

drawn across a window. That process was revealed in footage that was incorporated into the second portion of the exhibit, but that revelation was neither obvious, nor helpful, to the audience, for the monitor upon which it was playing was not merely turned to face the wall but placed right up against that wall. All that was visible was the glow of white light reflected off the surface; there was little to "see" at all.

Highlighting the idea that little about surface appearance is actually the truth of what is seen, Hu Xiaoyuan's work speaks of a broad fact of existence. Whether it be age that creeps upon us unawares, sickness that infiltrates a body unseen, climate change at work altering weather patterns around us, or the results of corruption and deception in business or government, between friends and foes, so much that directs and affects our lives might unfold before our eyes, yet we see as much or as little of it as the motion of Hu Xiaoyuan's curtain of paper. Even where we do see something apparently so slight, the mind resists reading them as signs, impatient instead for something it can understand; something that is easy to read and move on from, and that does not require perplexing thought processes.

To wit, a second video work, *Drown Dust*, which was one of those beautiful accidents of creativity that occurs when, in the process of carrying out a plan towards one conceived end, the artist discovers something else entirely, which directs them towards a rather different end—*Drown Dust* was created in the process of filming *Axing Ice to Cross the Sea*, 2012. At times, this may lead the artist to abandon the original concept, but in Hu Xiaoyuan's case it served to enhance it. *Drown Dust* is, in essence, the perfect complement to *Axing Ice to Cross the Sea*.

In substance and visual components, *Drown Dust* couldn't be simpler. The three

🛦 *See* (detail), video installation, dimensions variable, 2012

sequences follow details of the props and elements brought to *Axing Ice to Cross the Sea* as they touched the actor and the artist: sea water drips from a soaked garment; grains of sand are seen clinging to the interior of a drying shell; threads along the frayed edge of a piece of fabric waver and shake. Using a macro lens, Hu Xiaoyuan transformed these details into a world of their own. We are drawn into the journey of the drips, into the papery shadows of the shell, along the diversions of the stubbly edge, as if carried into an unknown and fabled land, for the imagination is very much awakened here, in the process of looking, and what it tells the viewer of the artist's intention is very much down to the breadth of their own imagination's bandwidth.

To complete *Drown Dust*, Hu Xiaoyuan put *Axing Ice to Cross the Sea* on hold, but there were aesthetic reasons for the delay too. The choice of timing—to finish filming in late December—had everything to do with a degree of cold, of frost, and the crisply cutting chill of air and atmosphere that cannot be faked; especially a sea that was wintry, but not frozen, or waves would not crash the shore. *Axing Ice to Cross the Sea* is a three-channel work centred on the distinctive movements of a friend of the artist, a writer and dancer, chosen for her androgynous demeanour and character. The video sequences were filmed on the coast of Hebei province, by the sea as Changli. It was in the course of setting up and then returning from the set—wet, cold and exhausted—that the elements in *Drown Dust* revealed themselves to Hu Xiaoyuan.

The different ways in which viewers responded to *Axing Ice to Cross the Sea* and *Drown Dust* may be telling. They might appear different, but are, in fact, related aspects of the same thing. If we looked at the works long enough, we'd probably figure it out. So whilst the artist uses this mechanism to challenge the pace at which art is experienced today, perhaps what Hu Xiaoyuan really wants to say is that there are no absolute answers. We need to rely on our senses, which demands patience and intuition in equal measure.

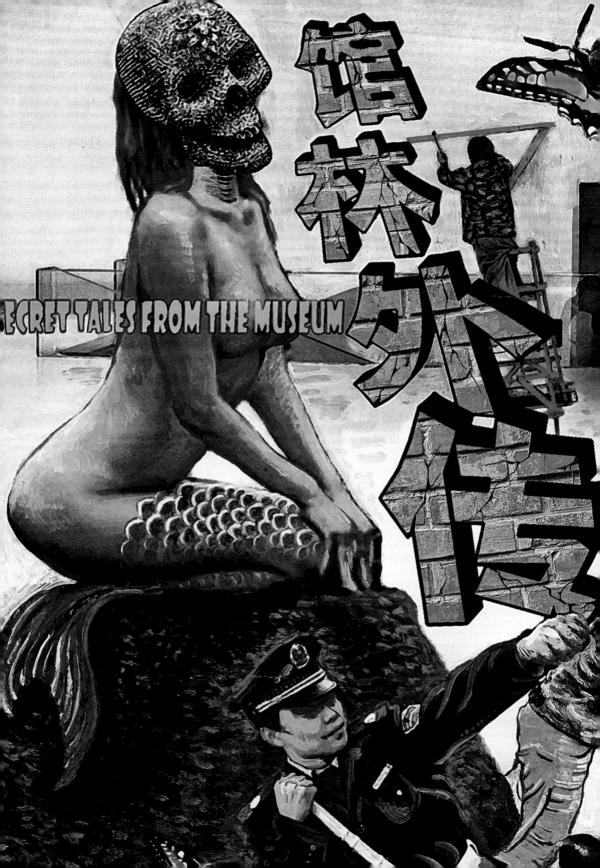

曹斐 | Cao Fei

Secret Tales from the Museum

*Beijing-based Cao Fei (b. 1978; Guangzhou) graduated from the
Guangzhou Academy of Fine Arts in 2001.*

The number of museums opening in China has reached astonishing proportions. At a
time when funding cuts in Europe and the US are forcing museums to rethink the way
they function and operate, and look at how their role as repositories of culture can be
managed on increasingly meagre means, the scale of museum building in China seems
ambitious. While the volume and range of cultural institutions in China has clearly lagged
behind that of Europe and the US, the rush to catch up is—like most other aspects of the
nation's development—as exhilarating as it is alarming. Sometimes it feels that, all too
randomly, museum buildings are constructed without proper specs or defined functions.
Fantasy is a thin veneer on impracticality. But then, ever since Frank Gehry's curvaceous
design for Bilbao's Guggenheim, the argument for straight, flat walls, which once seemed
de rigueur for an exhibition space, has lost ground. Painting is, after all, far from the only
form of art acceptable to museums, even in China, which, not so long ago it should be
noted, formally outlawed installation and performance. Concerning the latter, the official
jury is still out.

Cao Fei has long been a pioneer of artistic expression, beginning with MTV-
style video works and art-house documentary videos, and continuing with a protracted
journey into cyberspace, where the online virtual world of Second Life was invoked as
a platform for a fully rounded experiment in breaking new artistic ground. This was a
world Cao Fei named *RMB City*, which embraced architecture in the same measure as
social networking, sociological and cultural theory, art and all its institutions—aided by
the participation of living relations from the real world—and which even resulted in a full
opera (of the same name) that crossed over the virtual threshold and was performed
in the real world to widespread acclaim. *Secret Tales from the Museum* expanded Cao
Fei's repertoire in a literary vein in the form of a seven-chapter novella. Text went hand in

◀ cover illustration by Wang Buke, 2012

▲ *Secret Tales from the Museum*, colour photograph, by Zhao Zhao, 2012

hand with a series of photo works produced in collaboration with Beijing-based artist Zhao Zhao, and which, through a mix of familiar real locations and surreal auras, provided a provocative visual complement.

As explained in the title, the text comprised a series of tales related to the museum—strictly speaking to the art world in general—each one "told" by a fictional character. The characters here are stereotypes, such as security guards, cleaners, a typesetter and an artist's assistant (of a type immediately recognisable to readers in China), chosen for the innocent, untutored eye with which they bear witness to various aspects of art, artists, exhibitions and the museum as an institution. Cao Fei has always deployed a deft sense of humour in her work. This lent *Secret Tales from the Museum* particular appeal. The art world is an easy target for satire and parody: its eccentricities and egos are extreme. But for me, the strength of Cao Fei's vignettes lay in her artful evocation of the view of ordinary people looking at the "madness of the art world", but with very particular relevance to China: her true-to-life observations are entwined with serious issues of the times.

Chapter One begins with the mumbling of a museum guard, irritated by the "damn visitors ... always reaching over the security line to touch the head of the turtle: this is not a temple." The seemingly casual comparison between museum and temple is a reminder of how far art has departed from the aura of awe-inspiring mystery that, as High Art, it was once believed to possess. This sense of a general lack of reverence towards art underscored the lot of the security guard featured in Chapter Three, called upon to

double up as a body in a performance work by an artist who, tellingly perhaps, directs the action rather than leads it. Reflecting on the dilemma such calls engender, the security guard decides that "None of us lowlife punks [working as security guards] have any skills; we're all fucking losers and misfits." Does that explain why the artist has no compunction in asking them to perform his vision—in this instance crawling on the floor through a specially created pool of what appears to be black ink—for a small fee? As he sinks into the shallow pool, the security guard finds himself thinking: "We've gotten the short end of the stick . . . crawling like dogs in black water." Cao Fei's tale becomes a self-fulfilling prophecy as the guard is overcome by the "black water" and ends up in hospital, but with a sizeable payoff for his pains—and to ensure no fault will be found with either artist or museum. It won't—the money is three times the promised fee—but implicit here is the lack of moral (as well as health and safety) guidelines that ought to protect unsuspecting individuals from a form of exploitation that has been seen all too often.

The questioning of such behaviour and values was also seen in Chapter Two, in which a janitor relates an artist's explanation of a work involving a particular breed of butterfly. "The black butterflies represent the Chinese people," the artist is described as saying. "I release them inside the museum. But they have nowhere to flee, no food to eat, no home to return to. They are a metaphor for the Chinese people's pursuit of freedom and liberty." Said janitor is mortified by the death of the butterflies and the mass mortality involved. It's a touch that both completes the artist's point—transforming a senseless loss of life into a pseudo-meaningful image of sacrifice—and Cao Fei's acerbic satire of artistic vision, ergo ego. This subtle means of addressing the dark nature of metaphor and expression also points to the paradoxical relationship between freedom and constraint within China's cultural arena.

Artistic practice was also the subject—or butt—of Chapter Four and Chapter Five. The former begins with the familiar "misprint" in an exhibition wall text of a Chinese character that is almost indistinguishable from another. The ensuing confusion between a typesetter who "barely managed to finish high school" and an artist who "if he changed into a different outfit . . . could pass for a street BBQer" was deliciously farcical. Initially fearful of reprisals for his mistake, the typesetter is taken aback when he finds himself face to face with the artist, who tells him: "Your mistake has made me think things over ... Kid, it's really a decree from Heaven." Thus, clumsy oversight is transformed into profoundly meaningful sign, and the concept of the exhibition reoriented accordingly.

In Chapter Five, a second janitor is seen to make practical use of materials formerly used in installation works, which are abandoned at the end of the exhibition period. She "recycles" meat from "the end of the two-week exhibition" when "most of it was still fresh enough to eat," and tens of thousands of eggs used by another artist. "Everyone received at least one large box," she says. "For two months we ate eggs every day."

The final chapter recounts the tale of a truck driver who has become useful to the art community by driving works from studios to exhibition sites and back again. Having seen that even "garbage can be art" depending on "how it's promoted", and realising that "good art can become a currency", he decides to accumulate some currency of his own and have each artist sign his truck, the compound value of all those signatures on a scale he barely dares imagine.

Secret Tales from the Museum, colour photograph, by Zhao Zhao, 2012

The varying degrees of truth in each of Cao Fei's tales may raise a smile and conjecture concerning the figures who inspired the characters in *Secret Tales from the Museum*, but almost more poignant still is the sense of the extraordinary obstacles surmounted, by whatever means possible, and not all of them "professional", in China's race to measure up to the international museum community. In the words of the artist's

assistant: "Think about it, a roughneck like me is even becoming part of the 'art scene'."
That, ironically, points to an irrefutable natural democracy at work in China—albeit one
which ought to impel an urgent reorientation of the debates about the nature of the
museums flourishing in its midst.

INDEX OF EXHIBITIONS

INTRODUCTION

Images of artworks that are featured in the introduction are included to give an extended view of exhibitions, and of meritorious works, that took place in the period taken as the focus in As Seen 2, *but that for reasons of space and the strength of those works which are discussed, could not be included.*

Zhang Xiaogang, Beijing Voice @ Pace Beijing, 798, Beijing, December 13, 2012 – February 28, 2013

Gao Weigang, Vice @ Platform China, Caochangdi, Beijing, October 20 – December 2, 102

Han Wuzhou, Sunset Vacuum Plug @ Taikang Space, Caochangdi, Beijing, September 27 – November 17, 2012

Sui Jianguo, Solo Exhibition @ Pace Beijing, 798, Beijing, March 3 – April 14, 2012

Zhang Peili, Until the End of the World @ Tang Contemporary, 798, Beijing, September 29 – November 20 2012

Yangzi, Yangzi's Room @ White Space, Caochangdi, Beijing, November 17, 2012 – February 24, 2013

Double Fly, CAFAM Future @ CAFAM, Beijing, August 8 – September 6, 2012

Wang Guangyi, Thing-in-Itself: Utopia, Pop, and Personal Theology @ Today Art Museum, Beijing, October 14 – November 27, 2012

GUEST: Curated by Madeln Company, Standing on the Shoulders of Little Clowns @ UCCA, 798, Beijing, April 15 – June 27, 2012

He An, Who is Alone Now Will Stay Alone Forever: He An Solo Exhibition @ TOP Contemporary Art Centre, Shanghai, April 27 – May 26, 2012

Xie Naning, Second Round with a Whip @ Galerie Urs Meile, Caochangdi, Beijing, November 10, 2012 – January, 13, 2013

Song Ta, CAFAM Future @ CAFAM, Beijing, August 8 – September 6, 2012

CONTENTS

Wang Sishun, Liminal Space @ Long March Space, 798, Beijing, July 1 – August 12, 2012

Hai Bo, Solo @ Pace Beijing Gallery, 798, Beijing, July 2 – September 1, 2012

Zhou Tao, Collector @ Video Bureau, Caochangdi, Beijing, July – August, 2012

Pei Li, Generation P @ Platform China, Caochangdi, Beijing, August 25 – October 7, 2012

Li Dafang, Throw-back - Jin Zhan's Messy Growth, His Language and His Relatives @ Galerie Urs Meile, Caochangdi, Beijing, September 1 – October 21, 2012

Liu Wei, Liu Wei @ Long March Space, 798, Beijing, September 1 – October 7, 2012

Geng Jianyi, Wu Zhi: 1985-2008 Geng Jianyi's Work @ Minsheng Art Museum, Shanghai, September 7 – October 12, 2012

Wang Wei, A Wall on the Wall—A Floor on the Floor @ Magician Space, 798, Beijing, September 13 – October 31, 2012

Zheng Guogu, Spirits Linger With Dust @ Vitamin Creative, Guangzhou, September 17 – December 1, 2012

Li Songsong, The One @ Pace Beijing Gallery, 798, Beijing, September 22 – October 20, 2012

Utopia Group, Trudge: Geography of Utopia Group @ Iberia Centre for the Arts, 798, Beijing, September 22 – October 15, 2012

Hu Yun, The Secret Garden: Reeves's Pheasant @ Guangzhou Triennial, Guangdong Art Museum, Guangzhou, September 28 – December 16, 2012

Chen Wei, All About Her Songs @ Art Mia, Caochangdi, Beijing, December 10, 2011 – February 18, 2012

A Forgettable Song @ Futures, CAFAM, Beijing, August 8 – September 6, 2012: Xian City @ The Ninth Shanghai Biennale, Shanghai Contemporary Art Museum, Shanghai, October 2, 2012 – March 31, 2013

Zhou Yilun, As there is Paradise as in Heaven @ Platform China, Caochangdi, Beijing, October 20 – December 2, 2012

Hu Xiaoyuan, No Fruit at the Root @ Beijing Commune, 798, Beijing, October 20, 2012 – January 28, 2013

Cao Fei, Secret Tales from the Museum @ Leap, China, December issue, 2012

ACKNOWLEDGEMENTS

As Seen would not have been possible without the concerted help of the editors Adrian Sandiford and Xu Jiangling, each of whom was diligent, exacting and supportive in equal measure. I would also like to thank Chinese translator Bai Bing for her efficient and intelligent solutions to the problems of translation, and Chinese language assistant Wu Yang.

Publisher Wu Xingyuan continues to support *As Seen* with enthusiasm. Thanks to all his staff at China World Publishing Corporation for their contributions, including De Xiao for the design and layout, and Dong Liang for coordinating and overseeing production.

As Seen 2 would also not have been possible without the individual artists, whose exhibitions through 2012 were rich and varied, as was the extraordinary nature of the art world in China. It would not have been possible to see the works by artists included here if not for the institutions and galleries who support them. The role played by curators and directors is essential and is hereby credited. I'd also like to credit the many individuals who shared their comments and responses with me, providing valuable guidance and advice; Jim Cheatle, and others who prefer to remain anonymous.

Finally, I would like to thank Philip Tinari, director of the UCCA for co-publishing this volume. UCCA remains a lynchpin of the Beijing art world, although the significance of its exhibitions and institutional activities extends throughout China and beyond.

Thanks, too, to those institutions, galleries and artists' agents who provided additional images. Any error of omittance is entirely mine.

图书在版编目（CIP）数据

发光体 : As Seen. 2 : 英文 / (英) 史密斯(Smith,K.) 著. —— 北京 : 世界图书出版公司
北京公司, 2013.3
ISBN 978-7-5100-5833-2

Ⅰ. ①发… Ⅱ. ①史… Ⅲ. ①艺术评论—中国—现代—英文 Ⅳ. ①J052

中国版本图书馆CIP数据核字(2013)第036082号

发光体2号：亲历中国当代艺术现场
As Seen 2: Notable Artworks by Chinese Artists

著　者：（英）凯伦·史密斯（Karen Smith）

筹划出版：银杏树下　　　　**出版统筹：**吴兴元　　　　**编辑统筹：**董 良

责任编辑：德 晓　徐江玲　　**营销推广：**ONEBOOK　　**装帧制造：**墨白空间·德 晓

出　　版：世界图书出版公司北京公司

出 版 人：张跃明

发　　行：世界图书出版公司北京公司（北京朝内大街137号　邮编 100010）

销　　售：各地新华书店

印　　刷：北京图文天地制版印刷有限公司

（如存在文字不清、漏印、缺页、倒页、脱页等印装问题，请与承印厂联系调换。联系电话：010-84488980）

开　　本：720×1030 毫米 1/16

印　　张：14　　　　**插　页：**2

字　　数：261千

版　　次：2013年6月第1版

印　　次：2013年6月第1次印刷

读者服务：reader@hinabook.com 139-1140-1220

投稿邮箱：onebook@hinabook.com 133-6631-2326

购书服务：buy@hinabook.com 133-6657-3072

网上订购：www.hinabook.com（后浪官网）

ISBN 978-7-5100-5833-2　　　　　　　　　　　　　　　　　**定价：150.00元**

后浪出版咨询（北京）有限公司常年法律顾问：北京大成律师事务所　周天晖　copyright@hinabook.com